PARIS: PHOTOGRAPHS FROM A TIME THAT WAS

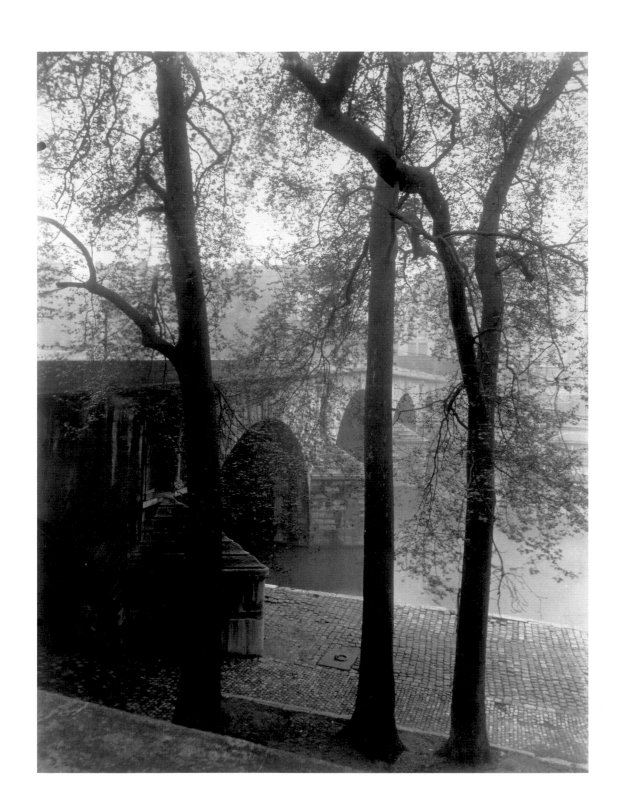

PARIS

PHOTOGRAPHS

FROM A TIME THAT WAS

David Travis

The Art Institute of Chicago

Yale University Press, New Haven and London

Paris: Photographs from a Time That Was has been published in conjunction with an exhibition organized by the Art Institute of Chicago and presented from August 13 to November 6, 2005.

First edition
Printed in Italy

Published by the Art Institute of Chicago
111 South Michigan Avenue
Chicago, Illinois 60603-6110
www.artic.edu

Distributed by Yale University Press, New Haven and London
www.yalebooks.com

Library of Congress Control Number: 2005927365

ISBN 0-300-11393-5

Cover: Else Thalemann. *Eiffel Tower, Paris*, c. 1930. Gelatin silver print; 12.6 x 17.7 cm. Restricted gift of Helen Harvey Mills, 1986.153.

Page 2: Eugène Atget. *Pont Marie*, 1927. Albumen print; 22.9 x 17.2 cm. Mary L. and Leigh B. Block Endowment, 1994.42.

Page 8: Brassaï. *Parisian Paving Stones*, 1929. Gelatin silver print; 8.3 x 5.8 cm. Restricted gift of Anstiss and Ronald Krueck in honor of the birth of Angelica Catherine Evan-Cook, 1997.409.

PREFACE AND ACKNOWLEDGMENTS

Walter Benjamin may have been right to call Paris the capital of the nineteenth century, but Gertrude Stein was equally correct when she said semi-cryptically that Paris was where the twentieth century was. Although not directed to it, her remark has proven to be true in the field of photography, which was marked in that period by dramatic experimentation and innovation in the French capital.

Birthplace of the daguerreotype, which was revealed to an astounded public in 1839, Paris never lost its leadership in pioneering new uses for photography. Our selection here contains several masterpieces from the medium's first sixty years by Gustave Le Gray, Charles Marville, Charles Soulier, and later Eugène Atget that show not only vistas of the city itself but views of the forest of Fontainebleau and the palatial grounds of Versailles. The next era, the *belle époque*, was essentially defined by Paris. In photography, its expression is best seen in the marvelous work of the child photographer Jacques-Henri Lartigue, whose spontaneous snapshots captured fleeting moments in the life of his upper-class family. Still, another great age was yet ahead for the City of Light. The period of the 1920s and 1930s in Paris was unrivaled in its explosion of images and ideas. Embraced by the various avant-garde movements, as well as by adventurous publishers and journalists, photography blossomed in its many forms.

Happily, many of the pictures of this rich period also have Paris as their nominal subject. They do differ, however, from the building facades and grand vistas of the early masters. The new vision proved to be highly personal, mobile, and intimate. The character of the subject in the modern era was understood through a unique point of view chosen at a unique moment of time. Details abound, but no photographer tried to pretend that Paris could be found in a single transcendental slice of life. With enough photographs of the various aspects of the city, however, a sense of the character of the many Parises emerges. Rather than showing static architectural environments, these photographers addressed the feeling that the metropolis was a place to create an existence of one's own. That attitude toward picture making was incorporated into the new documentary goals and styles that developed concurrently with the growing use of the photograph as a published image.

After studying a critical mass of works by master photographers in the collection of the Art Institute, curator David Travis realized that something of fundamental importance happened in Paris that did not quite happen elsewhere, certainly not to the same extent or as deeply. His essay elucidates his discovery of how and when the element of time—after being variously defined by both scientists and philosophers—came to shape photographic compositions. Although fragments of this story have been told elsewhere, wedded to other ideas about the replication of objects, this is the first time that the subject has been thoroughly addressed through the larger framework provided by great minds outside of the medium itself: Saint Augustine, Henri Poincaré, Albert Einstein, Henri Bergson, and Kurt Gödel.

The exhibition of French photographs at the Art Institute of Chicago has a long and rich history, which includes a number of landmark shows. André Kertész, Brassaï, and Ed Van der Elsken had their first one-person exhibitions in an American museum at the Art Institute in 1946, 1954, and 1955, respectively. Photographs from the 1954 and 1955 exhibitions entered our collection, and important works by Eugène Atget and Henri Cartier-Bresson followed in the 1960s. Our holdings of French photographs grew most substantially after the acquisition of the Julien Levy Collection in the 1970s. Levy had provided Berenice Abbott with the funds to save the Atget archive after the great photographer died in 1927. He was also an annual visitor to Paris in the later 1920s and 1930s, acquiring works by the many talents active in that fruitful period. Cartier-Bresson's first exhibition was held at Levy's New York gallery in 1933, and photographs from that historic event are reproduced here. The Levy collection also contained many other important pieces, including significant works by Kertész. Additional Parisian photographs by this pioneer of photo reportage entered the collection during our preparation for *André Kertész: Of Paris and New York* in 1985, the last major exhibition before the photographer's death. As we gained a clearer view of the importance of photographers who worked in Paris, other additions were sought and purchased individually or in small groups.

As with most museums, our collections would not exist without the assistance and the patronage of many individuals, families, corporations, support groups, and photographers. The generosity of

each donor is credited under the reproduction of the photographs they helped us to acquire. We are also grateful to those who read the essay as it was being shaped: Tom Bamberger, Katherine Bussard, Anstiss Krueck, Elizabeth Siegel, Irene Siegel, and Leslie Travis. Additional thanks go to Amanda Freymann, Sarah Hoadley, and Katie Reilly in the Publications Department and Nicole Eckenrode in the Department of Graphic Design, Photographic, and Communication Services. Their commitment to this book was critical to its production.

We, of course, realize that Paris is a subject larger than the photography, literature, science, art, history, or philosophy that the city created or fostered. We can agree, however, with Honoré de Balzac when he wrote in *Physiologie du Mariage* (1829) about how one needs to approach Paris visually, which in our case we have translated as photographically:

Most people walk around Paris as they eat, as they live: without thinking. . . . What a mistake to make in Paris! Lovely and delicious in her ways. Flânerie is a science, the gastronomy of the eye.

■ ■ ■

James Cuno
President and Eloise W. Martin Director
The Art Institute of Chicago

7

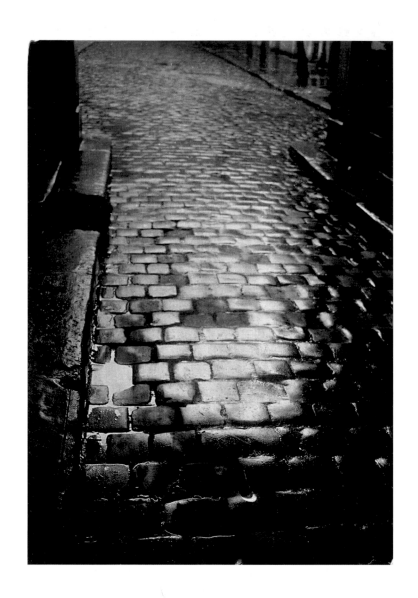

PARIS: PHOTOGRAPHS FROM A TIME THAT WAS

*If you are lucky enough to have lived in Paris as a young man, then wherever you go
for the rest of your life, it stays with you, for Paris is a moveable feast.*

— Ernest Hemingway, 1950[1]

*The writer has time to reflect. . . . But for photographers,
what has gone, has gone forever.*

— Henri Cartier-Bresson, 1952[2]

ON THE STREETS OF PARIS

Rue Plâtrière is gone, perhaps forever. The physical street is still in Paris, halfway between the seventeenth-century Palais Royal and the twentieth-century multiuse, multilevel mall of the Forum des Halles. It is the name that has been changed to commemorate a former resident, a figure so famous that even those not acquainted with him personally nevertheless recognized his slender physique on the street as he took habitual walks, referring to him simply as Jean-Jacques.[3] Rousseau lived on rue Plâtrière in a modest apartment toward the end of his life (1770–78). There he wrote a fascinating manuscript after making long, contemplative explorations of the city by himself on foot. He called these essays just what they were: *Reveries of the Solitary Walker* (*Les Rêveries du promeneur solitaire*).

Paris has long been a city for walking and reverie. When Rousseau went strolling through and beyond Paris in his later years, he was not seeking the distraction of the city's shops or its street life. As he wrote, he used his walks for "the pleasure of conversing with my soul."[4] He mused to himself that as a younger person he would have drawn on various happenstance encounters as an impetus for creativity rather than recollection. In his old age, he finally confined himself, he admitted, "to what was in my reach and [I] did not attempt to understand what was beyond me."[5] It is not a level of wisdom that everyone who falls in love with Paris can attain.

In the century after Rousseau, Paris fostered the creation of a new kind of walker and observer of its streets. The growth of a bourgeoisie with leisure time in the nineteenth century led to the evolution of a public figure known as the *flâneur*. One kind of *flâneur* was simply an unconfined idler and attention seeker, such as the dandies who conspicuously accompanied their pet turtles by the arcade shops or down the sidewalks of fashionable boulevards near the Church of the Madeleine. Perhaps it was this kind of *flânerie* that Pierre Larousse's *Grand Dictionnaire universel du XIXe siècle* described in an 1872 entry on the subject as appealing only to "empty heads and ignoramuses." But the editors, without admiring them, admitted to another type of *flâneur*, one that tended to be more original and artistic and that could only be found in Paris.[6]

A positive response to *flânerie* had already been recorded in 1858 with the publication of Victor Fournel's *Ce qu'on voit dans les rues de Paris* (*What One Sees on the Streets of Paris*). Fournel embraced movement, chance, and mutability as the essence of modern life and the public space as a kind of theater. It would have made Rousseau smile to see Fournel's book published, as the philosopher and social critic had audaciously anticipated the same situation back in 1758: "Let the spectators become an entertainment to themselves."[7] Rousseau accepted and celebrated change, as had Michel de Montaigne, who wrote almost two centuries before: "I describe not the essence but the passage."[8]

When Gertrude Stein was writing about the Paris of her time in contrast to what had been, she remarked, "The nineteenth century knew just what to do with each man but the twentieth century inevitably was not to know and so Paris was the place to be."[9] In that light, the emergence of the *flâneur* was not a constructive advance when it occurred. This new character, however, who wanted so much to see and to be seen, would be the source of an urge to set down what was being observed that would become a virtue in the next century in the person of the photographer.

THE SNAPSHOT

Those who were without artistic talent but had time on their hands, as well as sufficient funds, could perfect skilled hobbies such as boating and photography. These pastimes and others began to have substantial followings in the last decade of the nineteenth century. When bicycling became popular in New York, Alfred Stieglitz was chagrined to find what he considered a fad occasionally equated to photography, which he was trying to establish as a legitimate art form. By the end of the first decade of the twentieth century,

wealthy idlers might also consider becoming amateur aeronauts or race car drivers, as the child photographer Jacques-Henri Lartigue witnessed and recorded in the antics of his family in and around Paris.

Lartigue, a child of privilege, was also a child of good luck. His caring father was an excellent amateur photographer and allowed his young son to use any number of cameras, sometimes providing him with a stool so that he would be tall enough to see through the viewfinder. Being the baby of an *haut bourgeois* family, Lartigue was the tag-along recorder of minor sporting events and dressy social outings in happy *belle époque* settings (see pp. 40–41). By the age of thirteen, he was an accomplished photographer, employing cameras of various formats that were designed to be highly portable and easy to use. This permitted a newer kind of photograph, a spontaneous picture taken somewhat casually with an exposure short enough to capture a fleeting moment of a fluid scene: the snapshot.

Astute snapshot photographers like Lartigue began to understand that quick reflexes between eye and hand, as well as a certain amount of patience, were necessary to record ephemeral events from their daily lives. If one dismissed the need for the requisite artistic composition in whatever style, it had technically become child's play to record what almost fifty years earlier Charles Baudelaire admired as a remarkable skill in the journalistic artist Constantin Guys. Guys's specialty was sketching courtesans, dancing girls in motion, and Parisian high society parading on the streets. But Baudelaire recognized another necessity that was

strictly the province of a child like Lartigue: the consumptive sensibility of youth: "But genius is only *childhood recovered* at will, childhood now endowed, for the purpose of expression, with virile organs and with the analytic spirit which enables it to arrange in proper order the sum total of the involuntarily collected material."[10] If Lartigue is any indication, perhaps it was even better to *be* a child than be *like* one.

Alfred Stieglitz sometimes, albeit rarely, referred to certain of his photographs as snapshots (see p. 39). The term was not a precise technical description but rather a loose one that meant several different things. One fundamental characteristic was the rapidity with which a picture was taken; the premeditation and exacting pose associated with cameras fixed to tripods were of secondary concern. Often getting the subject in the frame and the negative exposed was enough. Even though snapshots sometimes created inadvertent compositions of marvelous curiosity, they were not considered a branch of serious picture making, which required deliberate arrangement; in fact, they were more often used as examples of its antithesis. Consequently, no sophisticated critical theory of the snapshot developed, nor was a link forged with the new scientific or philosophic notions of time that were emerging at this moment. Although snapshots, common as they were, could be seen as engaging with the exact "now" of the present, the prevailing understanding of photographic time rested on the premise that photographs saved a moment in time— that is, that they themselves became an object of visual history, a piece of the past, a souvenir of time gone by.

A TIME OF TIMES

In the early twentieth century, the novelist Marcel Proust became obsessed with acquiring photographs of people with whom he was infatuated or who served as models for his many characters. As Brassaï, who greatly admired the writer, observed,

> In his battle against Time, that enemy of our precarious existence, ever on the offensive though never openly so, it was in photography, also born of an age-old longing to halt the moment, to wrest it from the flux of "durée" in order to "fix" it forever in a semblance of eternity, that Proust found his best ally.[11]

For Proust, portrait photographs—such as those from the Parisian studios Hermann, Martini, Nadar, Pierre Petit, Salomon, and especially Otto—that preserved a moment of an individual's visage and figure were a precious necessity. In freezing their subjects in time, photographs both recorded an actual person and provided a visual point of departure for Proust's development of characters. Potentially, these same pictures could take on further value: "Photographs, once they cease to be a reproduction of reality and show us things which no longer exist, acquire a certain dignity."[12]

These notions of photography and time have remained fundamental and enduring. They were, in fact, expressed with greatly renewed force in *La Chambre claire* (*Camera Lucida*), Roland Barthes's last critical work, in which he discussed, among other things, the discovery of a photograph of his deceased mother as a young woman and the way that it complicated his memory with its parallel and distant reality.[13] Barthes's comments reveal that what photographs were for Proust and his era are still what they are for most people today: pictures of objects, scenes, or people that once existed in front of the camera. Depending on one's sense of metaphysics, the image either was captured by the photographer or impressed itself upon the negative. Brassaï offered his opinion: "The photograph . . . is the emanation of the subject, the subject's impression on a sensitive plate, whatever the photographer's talent. In any case, for Proust it is a living double, even when the subject is dead."[14]

Even as Proust wrote and searched for lost time, an alternative view of the photograph, or at least the peculiar character of its relationship to the present, began to emerge in the form of the snapshot. Although kept in private albums, ignored by critical theorists, and practiced in general by carefree amateurs, these works occasionally expressed a revolutionary new attitude. Practitioners like the young Lartigue did not strive to create art or develop a documentary style. A child might care about his own memory without understanding that it can form a structured past. Thus, time was not history for Lartigue, even if his photographs might become a wistful souvenir of a day's fun in one of his many albums. Time was something wrapped up entirely in spontaneity—the now of the present that was relentlessly slipping ahead of measurable time, ahead of what was becoming the past. Most importantly for children's perception, spontaneity was a phenomenon of experience rather than intellection. It was the kind of time they knew best: the time of play. For an adult, say a jazz musician, spontaneity is the moment

that the spark of improvisation is perceived and performed on the spot within a set rhythm. But more familiarly, it is simply that common time in which we live and things happen.

The conception of time as a duality—as being both spontaneously experiential and predictably historical—had been troublesome to define since antiquity. Saint Augustine, in Book 11 of his *Confessions*, wrote: "What then is time? I know well enough what it is, provided that no one ask me; but if I am asked what it is and try to explain, I am baffled."[15] Not satisfied with his vague answer, he perseveres, constantly asking for divine guidance, and presents us with the most beautiful definition of time ever written:

> *I say that I measure time in my mind. For everything which happens leaves an impression on it, and this impression remains after the thing itself has ceased to be. It is the impression that I measure, since it is still present, not the thing itself, which makes the impression as it passes and then moves into the past. When I measure time it is this impression that I measure. Either, then, this is what time is, or else I do not measure time at all.*[16]

In the playful atmosphere of his hobby, Lartigue explored what he enjoyed within the immediacy of the present, but adults, in the remoteness and seriousness of the hard sciences, found that their investigations of new notions of time produced enormous complexities. Because spontaneous (rather than passing) time was inextricably bound to the concept of simultaneity, when the French mathematician Henri Poincaré addressed the consequences of measuring simultaneity in a 1904 lecture, his ideas came extremely close to what would become Albert Einstein's theory of special relativity. From that point on nothing about time would ever be simple again.

In the twentieth century, first Einstein and later the mathematician and logician Kurt Gödel made further headway with the profound problem, striving to define time mathematically. Of particular interest was the question of whether a simultaneity—the exact now of a universal time—could exist between various frames of reference within the universe itself. The difficulty of not being able to treat time objectively found a solution in 1905, when Einstein positioned time as the fourth dimension. After this, the scientific world was gratefully at ease.

Time remained a bothersome issue in another arena: philosophy. In 1908 the British philosopher J. M. E. McTaggert published a paper examining the problem titled "The Unreality of Time." His analysis tried to classify our sense of time by referring to the dynamic temporal flux of past-present-future as "A-series time." The time that Proust studied, the time of past events stable enough to have a static position that could be measured and ordered, was labeled "B-series time." McTaggert claimed that B could not exist without A, but that A itself was unreal. It is no wonder that the closer Lartigue got to spontaneous events, the more curious his pictures became. One would have thought that Einstein's solution would have satisfied both photographers and philosophers. But the fact of the matter was that time's intricate placement in the general theory of relativity (1916) was, unbeknownst to Einstein, precariously unreal. The situation was not rigorously examined until Gödel probed its consequences in a

13

1949 paper. Gödel, mathematically more precise than McTaggert, came to a formalistically logical but intuitively bizarre conclusion that Einstein had not anticipated: time may not exist at all.[17]

Of course, for the rest of humanity, life does not stop because no one knows exactly if or what time is. The seasons change and the sun rises and sets for everyone, just as it did for Ptolemy and Newton. Many just accept what is convenient and go on to other matters. It can be extremely productive to work without an authoritative definition lording over all artistic experiments or even a bit of casual picture taking. As photographers were generally isolated from both astrophysicists and philosophers, they were free to deal with time in their own way. One might say that for a few visionary photographers, time became a dimension of special importance in the representation of objects or space. What resulted in their work was the creation of an image *shaped primarily by time*. This is what was advanced step-by-step in photography in Paris in a public way in the late 1920s and 1930s and can now be recognized as one of the crowning glories of the medium. It was pioneered by little-known and underappreciated photographers, and it occurred just after or was concurrent with the grand achievements in physics and a host of celebrated and expendable theories of art.

STARTING WITH ATGET

Born one generation before Proust, Eugène Atget had no particular infatuation with *belle époque* characters and no appreciation for the new uses to which photography was being put in the 1920s. Nor is there any evidence that he cared about snapshots.

He saw the world, like Proust, in terms of the remnants of past culture and evocations of tradition. This did not, however, preclude him from making photographs of people and street fairs (see p. 38). Alive and immediate, street merchants and circuses were part of a continuing past, which meant that they could be added to his great opus of photographs that preserved the city he loved (see pp. 2, 51, 53–55). When Stein thought about the apparent antagonism of the works of tradition and the inventions artists make in their own period, she discovered a stable singularity in the French outlook that seemed to magically undo the opposition: "Paris, the place where tradition was so firm that they could look modern without being different, and where their acceptance of reality is so great that they could let any one have the emotion of unreality."[18] Her pronouncement, meant to describe the acceptance of work by Pablo Picasso or Francis Picabia, could equally apply to photographs by Atget.

Like other documentary photographers through the early twentieth century, Atget strove for anonymous impartiality. This made it possible for the first members of the Surrealist movement to embrace his work when they chanced upon it. Looking only at his photographs, they did not care that Atget himself was a artisan who likely believed that the best era of French culture was over and not likely to reestablish itself in their future. His allegiances would not have been with them and their conceptual innovations but rather with the accomplished photographers of the past: Gustave Le Gray capturing the trees in Fontainebleau (p. 30), Charles Marville recording streets about to be demolished to make way for Baron Haussmann's long, broad boulevards in the

1860s (pp. 32–33), and Charles Soulier composing beautiful city vistas along the Seine (pp. 29, 31). But most likely Atget accomplished what he did without knowing their work, as it was buried in libraries, archives, or in the collections of a few aficionados of Parisian history.

Atget and his photographs might have gone unnoticed by the younger generation except for the fact that he was working and living out his last days in Montparnasse at 17 *bis* rue Campagne-Première, one block east of Man Ray's studio at 31. Through Man Ray, Atget joined the ranks of different "predecessors" embraced by the Surrealists: the works of Hieronymus Bosch and Pieter Bruegel and the writing of the Marquis de Sade, the Comte de Lautréamont, and Arthur Rimbaud were considered proto-Surreal. It did not matter if the artist or writer was dead or if alive wanted to be so honored; they staked their claim. And the medium in which Atget worked was no barrier to their appreciation either. So long as the photographer did not inject within the photograph some dogmatic vision of the world or insist on a meaning that restricted the free imagination of the viewer, it could serve a Surrealist's purpose. After all, the movement had universal pretensions; in the words of one of its practitioners, Georges Hugnet, it was "first and foremost a method of investigation and contains in itself a force which has always existed, a faculty as permanent as dreaming."[19]

After Man Ray became infatuated with Atget's photographs, younger photographers apprenticing in his studio discovered and were inspired by them. The images appealed to photographers and publish-

ers of the 1920s and 1930s in several ways. First, they were unretouched, documentary prints, meaning that they partook of no manipulative styling. Second, Atget paid careful attention to light and composition. And third, his chanced-upon subjects had a curious appeal similar to the attraction that objects stumbled upon in the Saint-Ouen flea market had for the founder and arbiter of the Surrealist movement, André Breton: "I go there often, searching for objects that can be found nowhere else: old-fashioned, broken, useless, almost incomprehensible, even perverse."[20] Atget's images resonated with both the Surrealist sensibility and that of straight photographers: an old storefront that clearly renders dress forms displaying corsets (p. 51), or an even more evocative picture of the vacated human form, one that features two pairs of shoes and two chairs made for a midget and a giant, figures represented merely by framed photographic portraits (p. 53). The obsession with objects and what they might induce the imagination to conjure up was easily transferred to their surrogate: photographs. This, more than any sense of time, was the primary attraction that photographs held for the Surrealists.

Objects were the essence of the photogram technique that Man Ray rediscovered in 1922 in his darkroom. Recognizable items normally unassociated with each other—such as a glass-plate negative depicting the dismantling of the Ferris wheel in Paris and a folding carpenter's rule looking somewhat like an open hand (p. 44)—coincided as if by chance on the same piece of photographic paper to create an indefinable something that had not previously existed. For the Dadaists of the period—Surrealism would be founded two years later—the photogram,

or Rayograph, as he liked to call it, retained enough contempt for traditional picture making and maintained enough chaos to keep it from being predetermined and thus, for them, an abomination.

Most of Man Ray's photographs, like his paintings, were made indoors. Only on occasion did he photograph on the streets. Although Man Ray fed his craving for chance and experiment—he once made film footage to suggest an automobile crash by tossing his camera up in the air just to see what the result would be—he was a creature of the studio and worked out most of his ideas there. The photographers who apprenticed with him, by contrast (Berenice Abbott, Jacques-André Boiffard, Bill Brandt, and Lee Miller), did not have "studio" careers (see pp. 50, 52, 57). Excepting Boiffard, they were cultural immigrants like Man Ray. And they were not alone as strangers in Paris. Between Lartigue's early photography around 1902 and Henri Cartier-Bresson's first exhibition in 1933, most of the great photographers working in Paris were not born and bred French citizens. In addition to a few Americans and Russians, most arrived from Hungary (Rogi André, Brassaï, and André Kertész) or Germany (Ilse Bing, Horst P. Horst, Germaine Krull, or Else Thalemann, who only visited), some fleeing from fascist regimes (see pp. 49, 60–61, 69, 78). Photography was not then a glamorous or even a respectable profession, but, like journalism, it allowed a foreigner a way to make a living.

THE NEW PHOTOJOURNALISTS

Germaine Krull, whose father was French and mother German, lived in Paris until she was twelve and then spent her adolescence in Bavaria, where she studied to be a photographer. The portrait studio she established in Berlin was short lived; she moved to Amsterdam and then in 1924 to Paris, where Robert and Sonia Delaunay introduced her to artistic society. Through them in 1927, she met Eli Lotar, a Romanian who had been born in Paris but raised in Bucharest. He became a combination darkroom assistant and photographic partner. Krull's timing in leaving studio work for a freelance career as a photojournalist was nearly perfect. In 1928 she became the accompanying "eye" to writers whom Lucien Vogel hired to work for his new illustrated weekly magazine, *Vu*. She photographed the Eiffel Tower, the homeless *clochards* (vagrants) populating the banks of the Seine, and the produce markets of Les Halles (see p. 59). Her 1929 book, *100 x Paris*, printed in three languages by a German publisher, served as a visual guide for visitors and lovers of the city. In it she tried to avoid standard, dead-on frontal renditions of famous places and monuments by moving her camera to new points of view tucked away in alleys, high above the streets, or close to bustling pedestrian or motor traffic.

Another photographer who worked at *Vu* and illustrated magazines such as *Uhu, Variétés*, and *Die Dame* was André Kertész. He arrived in Paris from his native Budapest in 1925, with no background in a photographer's studio and no thought about one in his future. That Kertész did not learn to speak passable French for some time was not initially a handicap, as he first wanted to explore the city and take in its sights, street life, and artistic scene. In 1926 he met Piet Mondrian through a Belgian friend, the poet Michel Seuphor, and visited the

painter's studio to make photographs for a publication Seuphor was planning (see p. 46). That experience reinforced the value of the geometric compositions that he was encountering in works by almost every artist in his Hungarian circle, and his photographs gained a modern structure.

When asked toward the end of his life if he remembered the first time he saw Kertész, Cartier-Bresson claimed that he himself was still in short pants when he spied the older man in one of the grand cafés on boulevard Montparnasse.[21] This was Cartier-Bresson's way of saying that for him Kertész had always been the beloved first master of what he himself would later accomplish. Although he exaggerated greatly and was no boy, there is some truth in what he said. Kertész had come to Paris, perhaps naively believing that he could make it by photographing the great public spectacle of life on the street or human interest stories—something at which no one had made a living before. By morphing the role of a quiet and diligent *flâneur* into that of a photographer, he took on a mission to show others evidence that the world is a charmed place, revealed in the transitory incidentals it secretly flashes back in select moments to certain of its inhabitants.

Kertész and the photographers of his generation would have instantly accepted, had they read them, William James's ideas of the stream of consciousness (1890) and his claim that no state, once gone, can recur and be identical to what it was before. It was more likely that they had a conversational familiarity with the notion of *durée* (duration) that Henri Bergson published in 1907 in *Creative Evolution*, a book that surprised the author more than anyone

with its wide sales and readership. Elaborating on James's themes, Bergson emphasized that an individual's consciousness cannot go through the same state twice: even if a scene seems to never change, the observer will. His views refined a notion, shared by both snapshot photographers of his day and Montaigne in the sixteenth century, that life is observable and knowable not as an ossified state of being but in the act of becoming.[22] Because so many people had become amateur photographers by the turn of the century, Bergson confidently employed photographic metaphors when expressing some of his thoughts about change: "Form is only a snapshot view of a transition."[23]

To seek a point of transition, Krull sometimes photographed in moving automobiles, a radical idea at the time that underscored that both the subject and the photographer could be in motion. Kertész, too, devised ways of dealing with the flux of subject matter and the mobility of the camera. While he had his share of bird's-eye views (see p. 58), he more often found a vantage point like a geometrically set trap, took his position, and waited until a moving figure entered the composition. He also began to picture situations of simultaneity; he would find two unrelated figures walking or sleeping along the quais of the Seine and connect them in a potential narration (p. 62). Or he would spot a dog in the door of a bistro that might be linked to a cat around the corner and up the street (p. 64). One of his most famous photographs contrasts a finely dressed gentleman out for a stroll, walking stick in hand, looking toward or beyond two men in working clothes approaching him along the diagonal of a tree-lined boulevard (p. 43). Noticing the symbolic status of

these figures is unavoidable, but what subtly animates the photograph is the juxtaposition of motions: the gently tilting, slidelong stance of leisure and the forward gait of the workmen. Although Kertész was not given over entirely to exploring spontaneity or simultaneity, these were some of the first fruits of a new awareness of time as a shaping element of a photograph. For pioneers like Krull and Kertész, the sense of the moment became the primary reason for making many of their pictures. Thus, they finally achieved in photography what Baudelaire had written of seventy years before in response to Guys's sketches of the Paris streets: "The pleasure which we derive from the representation of the present, does not depend solely on the beauty with which it may be invested, but also on its essential quality as the present."[24] This new way of seeing, which developed out of making up visual stories, was not just a matter of recording subject matter; it was a personal quest in creating and understanding what a picture *shaped primarily by time* actually was.

Like Guys's sketches, such photographs did not often represent key political or historical events; nor were they required to be of important places. More often they were built upon trivial and personal moments. The new photojournalists, although conscious of objects and the symbolic meaning of their likenesses, developed a refined sense of timing and thus saw an extraordinary play of form in front of them that was invisible to anyone not thinking in this new photographic way. Their approach, however, had no name or verbal description. In 1928 the French novelist and journalist Pierre Mac Orlan tried to explain how the medium in the hands of

photographers such as Krull and Kertész could do more than a simply record objects: "[Documentary photography] is unwittingly literary, because it is nothing other than an observation of contemporary life apprehended at the right moment [*le bon moment*] by an artist capable of seizing it."[25] He continued,

> *The greatest field of photography, for the literary interpretation of life, consists, to my mind, in its latent power to create, as it were, death for a single second. Any thing or person is, at will, made to die for a moment of time so immeasurably small that the return to life is effected without consciousness of the great adventure.*[26]

The great adventure was not just the return to "life," but the completion of the action. Editors and art directors caught on quickly and created visual layouts for their weekly publications that told a story in pictures with the aid of captions or a short text.

The year 1930 seems to have been a high point for writers trying to describe the moving present that some photographers were realizing in their pictures. Mac Orlan had already written passionately and evocatively about the unique potential of the photographer's skill and medium: "Photography is an art of instinct. The decisive act can scarcely be expected to submit to laws of composition and rhythm comparable to those governing most of the plastic arts."[27] In 1930, in the first book of Atget's photographs, Mac Orlan expanded his earlier essays and described what he imagined Atget and younger photographers sought out on the public streets as the "fantastique social" (social fantastic)—the type

of fluid, quixotic subject infused with mystery that a *flâneur* would relish.[28]

In 1930 another writer, Pierre Bost, tried to pin down the elusive phenomenon of the moving present with a different phrase:

> *Ephemeral truth [vérité éphémère]? Yes. It is the strength of photography and at the same time the limit of its power. . . . It is said that photography is the only way by which we can know this instant, nearly approaching the unattainable and barely conceivable knowledge of the pure moment.*[29]

In the same year, the editor and writer Carlo Rim (the pseudonym for Jean Marius Richard) perceptively observed in an article called "De l'instantané" ("On the Snapshot"):

> *The snapshot flies in the face of time, violates it. Photography has given a material guise and body to time, which otherwise eludes our human grasp. It has given them to time the better to take them back again. And so it has destroyed the confused and eminently literary notion we have of the past. Thanks to the photograph, yesterday is no more than an endless today.*[30]

Although writers tried to define this way of seeing within life that went from instant to instant, it rested with the photographers themselves to discover the various characteristics of the new attitude they had created.

A variation of this new sense of time was developed in Paris by another immigrant, who came from Transylvania via Berlin. Gyula Halász, later known as

Brassaï, arrived in 1924, a year before Kertész, and at first earned a hand-to-mouth existence drawing and writing anything he could sell to Hungarian or German publishers. Sharing a language, the two men often found themselves within the same circle of friends. It seemed fated that soon after 1929, when Brassaï began to learn photography, he sought the assistance of Kertész, who gave him a great gift: the idea that, with a tripod and a long exposure, photographs could be taken at night (see pp. 48, 66–67).

Brassaï, who needed only about four daily hours of sleep, was already a devotee of the Parisian night and all it revealed about another side of life in the great cultural capital (see pp. 72–75).[31] When not up late reading Goethe, Nietzsche, Bergson, or books about history and science, he prowled among the *demi-monde* on his own or with the night-walking poet Jean-Paul Fargue. The American writer Henry Miller found Brassaï to be such a perfect companion that he wished to make him a character in a novel:

> *I want to include him for two reasons—first in honest tribute to his talent, second, because one of the principal themes of my book is the "street," and in cher Halász I find a counterpart to myself, I find a man whose curiosity is inexhaustible, a wanderer like myself who seeks no goal except to search perpetually.*[32]

Eventually, both Brassaï and Miller would gain recognition for this kind of "night" work: Brassaï in 1933 with his sensational *Paris du nuit* (*Paris at Night*) and Miller in 1934 with his controversial *Tropic of Cancer*.

Although Brassaï used a tripod for his street photography, it does not mean he did not recognize or deal with a moving present. He was likely better read in the matter than any other photographer. As a journalist, he had even attended the public lectures Einstein gave about relativity in Berlin. In a book on Hermann Lotze's metaphysics, he penciled a stray thought on the half-title page: "We run around the present like a dog around its strolling master. Sometimes it's ahead and sometimes it's behind, only sniffing its master's steps. It is never really with him, except on the rare occasion when it takes the piece of sugar he offers."[33] It seems to be a perfect description of the way a photographic exposure freezes time, except that Brassaï had little interest in representing the world in artificial split-second moments. He liked his subjects to be down-to-earth, stable, possessing a kind of movement that models for sculpture have. So when Brassaï implied that one meets the present as a picture only rarely, he meant only rarely, and not with every click of the shutter.

Brassaï's marginal notes in books by Henri Bergson indicate his appreciation of the philosopher's idea that reality is not understandable as individual particles or discrete essences—frozen moments so to speak; rather, reality is an inseparable continuum whose abiding character is a flow and duration (*durée*) that forges ahead of what becomes the past. For Brassaï this was a point of view with complex consequences. Although he realized that life must be lived in the present, he had no qualms about artificially setting up a scene otherwise impossible to photograph. Because he could not be candid when using the light of magnesium flash powder, he was forced to stage events

he had previously observed with the original subjects acting their parts (see pp. 70, 72). What counted for Brassaï was the emanation of the subject, staged or not, onto film rather than the chance of catching something unawares. He did not always use the camera as a tool to help separate reality from illusion; on the contrary, in his directorial mode, he often employed it to exchange one for the other, as when he pictured two hoodlums seemingly staring from around the corner of a building who are actually cut off of the edge of his glass-plate negative (p. 70). Nor did he glorify the camera as some ultimate mechanism of perception, or some metaphysical extension of sight. For him, all of that was connected to the human eye and the mind behind it, and not to any mechanical or optical apparatus. In his copy of Poincaré's *Science and Hypothesis*, he underscored a statement that could have been his slogan: "it is always with our senses that we use our instruments."[34]

Instruments are, however, important. There is probably not a photographer who used the 35 mm Leica camera who did not love it and give it partial credit for resulting successes. Of course, not every Leica produced a photographer of genius. Although it was not a tool for Brassaï, it became the camera of choice for Kertész, Ilse Bing (who became known as the Queen of the Leica), and, most famously, Cartier-Bresson. With its relative lightness, ease of handling, silent operation, and thirty-six-exposure roll film, it allowed photographers to capture the moment as it unfolded, mutated, and started to evaporate.

In 1931, at the peak of Kertész's activity in Paris, a then unknown, twenty-three-year-old Cartier-Bresson was convalescing in Marseilles from blackwater fever.

There, the next year, he made what he later called "instant drawings" with his Leica and in so doing developed a sense of picturing the present. This was all flavored with a bit of Surrealistic seasoning he had acquired a taste for a few years before in Paris, where he had also seen some of the great films of the period; images by Kertész, Krull, and Martin Munkacsi in the new picture press; and even a few of Atget's prints.[35] Beyond his eye for pictures, he had a way with words and stated the case for so many others when he wrote that his purpose as a photographer was simply "to preserve life in the act of living" (see pp. 63, 65, 71, 77, 95–96).[36]

When Irving Penn recently reminisced about meeting with Cartier-Bresson in 1962, it was to tell the story of how the famous photojournalist took a portrait of Penn with his brother Arthur, the stage and film director.[37] A quiet Frenchman a few years their senior arrived at Irving's apartment and sat down to talk and have tea. After a considerable time had elapsed, Penn asked when the session would begin, to which Cartier-Bresson replied that he already had the picture and pulled a Leica from his jacket pocket to show what kind of camera he had used. The portrait had been taken surreptitiously: Arthur is shown in the midst of a hand gesture and Irving is casually looking at him with his feet up on the coffee table. Penn then stated what had become obvious to him as Cartier-Bresson's way of working: "He's like a thief." Penn's perfect observation evokes the thought behind the original French title of *The Decisive Moment*, Cartier-Bresson's famous 1952 book: *Images à la sauvette*.[38] The French phrase *vendre à la sauvette* means to stealthily hawk merchandise on the street with one eye out for the police. Trying to be an invisible but honest man is what Cartier-Bresson settled for.

During the German occupation of Paris, most photography in public was banned, and thus capturing life in the act of living could not be done with a camera. Brassaï pursued a career as a writer and recorded "aural snapshots" of words he overheard working in a bar/tabac. He also frequently visited Picasso, conversing with him and photographing his studio and sculptural objects.[39] Pierre Jahan, who had done Surrealist collage work in the 1930s, also photographed objects in studios secretly at the time. He discovered an eccentric artist-poet who had assembled thousands of doll parts in his studio and he made a series of documentary photographs there with a Surrealist edge. Another find with a parallel character presented far greater danger. Jahan photographed the bronze public sculptures the Germans had stripped from throughout Paris and were then melting down as scrap metal for military use (see p. 80). At risk to his well-being and perhaps life, Jahan made a series of these anguished scenes that became a book in 1946 with a text by Jean Cocteau, *La Mort et la statues* (*Death and the Statues*). He had also documented the crating of the treasures of the Musée du Louvre before the invasion and their restoration after the liberation (see p. 81).

Several of the talented photographers who once inhabited the city were absent during the war. Cartier-Bresson was a prisoner of war for most of the conflict. Kertész had moved to New York in 1936. Krull escaped Paris in 1940 and spent time in the south of France; in 1942 she joined Charles de Gaulle and the Free French Forces in Algeria. Robert Doisneau, a young photographer who had

yet to make his name, remained in the region and aided the Resistance with his professional skills. He later took to the streets, taking pictures before and during the liberation of the city on August 25, 1944.

At the war's end, Doisneau decided to dedicate himself to photojournalism rather than resume commercial photography. He had a natural way with people and was easily accepted and trusted among those he photographed, no matter what their social status or profession. His preferred camera was the small, boxy Rolleiflex, which had one lens for focusing and composing the picture on a small ground-glass and another for making the exposure. Using the larger, slower Rollei proved to be no handicap for Doisneau who, like Brassaï, worked "far more with his personality than with the apparatus of photography to record his images."[40]

Unlike Lartigue or Cartier-Bresson, Doisneau came from a *petit bourgeois* family. His parents lived not in Paris but in small towns or the poorer *banlieue* (fringe suburbs) ringing the capital. He never felt comfortable traveling far from this milieu. In 1947 Cartier-Bresson and Robert Capa asked him to join the newly founded photo agency Magnum. The agency would become one of the most prestigious in the world, sending photographers on extended international assignments. Doisneau decided to stay local and close to his immediate family. Cartier-Bresson recalled him saying, "If I were to leave Montrouge, I would be lost."[41]

Doisneau shared the same determination as Kertész and Brassaï to use the life of the street as his school

and studio. His 1949 book with a text by the poet Blaise Cendrars, *La Banlieue de Paris*, expressed his desire to humanize the impersonal, drab outskirts of the city (see p. 88). It is a testament to his patience that he found such rich subjects in a setting that for most photographers held no promise at all. He also understood that time shaped the photograph: "It doesn't matter where you look, there's something going on. All you need to do is wait, and look for long enough until the curtain deigns to go up. So I wait and each time the same pompous formula trots through my head: Paris is a theater where you buy your seat by wasting time."[42]

Like Brassaï, Doisneau also had guides and accomplices in Paris, such as Robert Giraud, a poet, fellow Resistance fighter, and communist who introduced him to the underground world of *clochards* and eccentrics at the edge of respectable society. Through Giraud, Doisneau met Jacques Prévert, a Surrealist poet and fellow *flâneur* who helped him discover what was around them on the streets but remained invisible to everyone else. In this regard, Prévert was proud to refer to Doisneau as a *braconnier*, a poacher, which is in line with Cartier-Bresson's idea of taking an image *à la sauvette*.[43]

Many photographers, even if they were primarily interested in normal life on the street, managed to function within both a *demi-monde* environment and the world of high fashion. Doisneau tried to partake of both, but felt out of place in either. In 1950 French *Vogue* offered him the major assignment of creating a photographic series about the *petits métiers* of the capital. These independent street merchants and tradesmen had been photographed at the turn

of the century by Atget and others. The editors wanted studio portraits, but Doisneau would have only been comfortable picturing them in situ in their unglamorous, out-of-the-way ateliers. The job was given to Irving Penn, who was in Paris on his first extended assignment for American *Vogue*, covering the new fashions and making portraits of artists and writers. He rented an old daylight studio in Montparnasse, and the features editor of French *Vogue*, Edmonde Charles-Roux, supplied him with various tradesmen with their wares (see p. 84).[44] It was there that he also made several of his famous fashion photographs (see p. 85).

After the war and the privation that followed, Paris still attracted a wide variety of writers, artists, and photographers. Some came to picture places and objects of the romantic city, but others were attracted by the life of the streets. Robert Frank arrived from Switzerland via the United States, where he had begun working for *Harper's Bazaar* and its influential art director Alexey Brodovitch. On various visits from 1949 to 1951, already sensitive to how time shaped photographs, he recorded vignettes of Paris street life that are darker in tone than Kertész's, yet retain a certain charm and even optimism (see pp. 93, 99). The beginning of a psychological dimension is just evident. In pursuing that attitude, by 1957 he came to see the element of time playing a slightly different role in photography, signaling the commencement of a new period: "It is always the instantaneous reaction to oneself that produces a photograph."[45]

From Holland came Ed Van der Elsken, a hopeful, young, penniless photographer armed with a Rolleiflex who, like others of his generation, was searching for a way out of the dark days following the war. He fell in love with a mysterious woman named Ann and made a long series of moody photographs of her and her friends (see p. 91). This resulted in a new kind of book about Paris, *Love on the Left Bank* (1957), an improvised story with a psychological atmosphere that progresses much like a sequence in a silent film punctuated by a few captions. Although almost none of the photographs are completely candid, they were of subjects playing their own roles. The staging of certain pictures was the result of the photographer envisioning the composition and storyline he wanted and achieving it by reenactment. Brassaï had used this procedure, and in 1950 Doisneau had adopted it for one of his most famous images, although not one of his favorites: a couple kissing among a busy crowd outside the Hôtel de Ville (p. 89). And although the photograph centers our attention on the subject, our understanding of the image is now entirely informed by the pictures of time that Krull and Kertész had pioneered.

The subject of lovers kissing in public, as the clichéd theme of romance in Paris, turned out to be very popular with the readers of *Life* magazine, which had commissioned the series from Doisneau. It was never stated that the photographer had employed models, but it probably would not have mattered. American editors were projecting Paris back onto itself in such assignments, knowing what their readers wanted, whether fabricated or not. Using models may have been an assignment photographer's practical solution, but in another sense, it may have been a way of updating Rousseau's suggestion: let the spectators' *expectations* become a kind of *self-fulfilling* enter-

23

tainment through this new medium. Or it may even be related to a more extreme perception of what Gödel believed about the world: "Only fables present the world as it should be and as if it had meaning."[46] Thus, the idea of not only editorialized, but staged, photojournalism began to emerge.

Between 1957 and 1960, Ernest Hemingway wrote about his experiences in Paris, some three decades after sitting in the Cloiserie des Lilas when he was first trying to become a writer. No longer in Paris, but traveling between Cuba, Spain, and Idaho in his last years, he had time to reflect on the city and his life. In his reminiscence, perhaps he believed that an inspiring Paris was still there, waiting to foster the imagination of yet another genius. "There is never any ending to Paris and the memory of each person who has lived in it differs from that of any other. We always returned to it no matter who we were or how it was changed or with what difficulties, or ease, it could be reached."[47]

The idea that there was never any ending to Paris has a completely different sense in Gödel's dispassionate mind, even though he never lived there. That neverending Paris was not a romantic literary idea but rather one wild in its impersonal, mental exaggeration, in some remote, improbable, yet-to-be-discovered, rotating universe that followed his complicated formalistic logic and calculations within the theory of general relativity. If Paris or anything is there in that strange Gödel universe, it loops around predetermined tracks catching up with its past, a strange

echo of the lighthearted idea of the "endless today" that Carlo Rim wrote of two decades before. Proving that in certain cases time can be shown *not* to exist, Gödel questioned whether it *can* logically exist anywhere else. Even if such a universe is real, the rest of us would likely choose to ignore it or believe it is only a form in theory in the way we accept black holes. After all, on the practical side of life that we must live in, there remains available to us only a human, intuitive option.

Even though the taking of a photograph may be a patient act conceived and completed as some event in an A-series experience—within the private immediacy of an unfolding moment—the resulting reverie is nevertheless a picture to be shared with an audience and not a theorist's attempt to define time. That is one reason photographs are a welcome solution for a recognition of either spontaneous or historic time or any number of Parises. Photographs worked one way for Proust and Atget, differently for Lartigue, and in still another way for Kertész, Cartier-Bresson, and Doisneau. And even if this reverie in photographic form has acquired a marvelous configuration because of a new awareness of time pictured and perfected in Paris, we, nevertheless, insist that photographs meld into a comfortable notion of the past. So, one way or another, all those brilliantly spontaneous pictures of life lived instant by instant in that novel, impulsive city inevitably become testaments to and photographs of a time that was.

24

NOTES

1 Ernest Hemingway, *A Moveable Feast* (New York: Charles Scribner's Sons, 1964), title page. Noted as "to a friend."

2 Henri Cartier-Bresson, *The Decisive Moment* (New York: Simon and Schuster, 1952), n.pag., repr. in *Photographers on Photography*, ed. Nathan Lyons (Englewood Cliffs, N.J.: Prentice-Hall; Rochester, N.Y.: George Eastman House, 1966), p. 44.

3 The section of the street northeast of the Bourse running from rue Coquillière to rue Étienne Marcel was renamed in 1791; the section to the southwest running from rue Saint-Honoré to rue du Louvre was renamed in 1868.

4 Jean-Jacques Rousseau, *Reveries of the Solitary Walker*, trans. Peter France (London: Penguin Books, 1979), p. 32.

5 Ibid., p. 59.

6 Pierre Larousse, *Grand Dictionnaire universel du XIXe siècle* (Paris: Grand Dictionnaire universel, 1872), vol. F–G, p. 436.

7 Jean-Jacques Rousseau, *Politics and the Arts: Letter to M. d'Alembert on the Theatre*, trans. Allan Bloom (Ithaca, N.Y.: Cornell University Press, 1968), p. 126.

8 Rousseau (note 4), p. 12. The Rousseau translator, Peter France, used the 1604 John Florio translation of Montaigne's essay "Of Repentance"; see note 22 below.

9 Gertrude Stein, *Paris France* (New York: Liveright, 1996), p. 13.

10 Charles Baudelaire, "Peintre de la vie moderne," repr. and trans. in *The Painter of Victorian Life: A Study of Constantin Guys*, ed. Geoffrey Holme (London: Studio, 1930), p. 44.

11 Brassaï, *Proust in the Power of Photography*, trans. Richard Howard (University of Chicago Press, 2001), p. xi.

12 Marcel Proust, quoted in ibid., p. 23.

13 Roland Barthes, *Camera Lucida: Reflections on Photography*, trans. Richard Howard (New York: Hill and Wang, 1981), starting on p. 63.

14 Brassaï (note 11), p. 83.

15 Saint Augustine, *Confessions* (Baltimore: Penguin Books, 1968), p. 264.

16 Ibid., p. 276.

17 For the most lucid discussion of the complicated definition of time, see Palle Yourgrau, *A World without Time: The Forgotten Legacy of Gödel and Einstein* (New York: Basic Books, 2005), pp. 119–43. Some astrophysicists dismissed Gödel as having made a mistake, which later proved not to be true. Einstein did not object, but was known for being resistant to the oddities of strictly mathematical situations. For instance, he resisted the idea of black holes when they were suggested, because they had only been proposed mathematically.

18 Stein (note 9), p. 18.

19 "Georges Hugnet, 1870 to 1936," in *Surrealism*, ed. Herbert Read (New York: Praeger Publishers, 1971), p. 188.

20 André Breton, *Nadja*, trans. Richard Howard (New York: Grove Press, 1960), p. 52.

21 Henri Cartier-Bresson, in conversation with the author.

22 Montaigne's original wording in his essay is "Je ne peints pas l'estre. Je peints le passage"; see *Les Essais de Montaigne*, 3rd ed., vol. 2 (Paris: Presses universitaires de France, 1978), p. 805. Here I follow Donald M. Frame's translation (1943) of *l'estre* and *le passage* as *being* and *becoming*, rather than John Florio's rendering (1604) of the terms as *essence* and *passing*.

23 Henri Bergson, *Creative Evolution*, trans. Arthur Mitchell (Lanham, Md.: United Press of America, 1983), p. 302. For Henry James, see "Stream of Thought" in *Principles of Psychology* (1890).

24 Baudelaire (note 10), pp. 16–18.

25 Pierre Mac Orlan, quoted in Sarah Greenough, et al., *On the Art of Fixing a Shadow: One Hundred and Fifty Years of Photography* (Washington, D.C.: National Gallery of Art; Art Institute of Chicago, 1989), p. 239.

26 Ibid.

27 Pierre Mac Orlan, "Éléments de fantastique social," *Le Crapouillet* (Mar. 1929), repr. and trans. in *Photography in the Modern Era: European Documents and Critical Writings, 1913–1940*, ed. Christopher Phillips (New York: Aperture, 1989), p. 33.

28 Mac Orlan's idea of the social fantastic appears in "Éléments de fantastique social" (note 27) and in his preface to *Atget photographe de Paris* (New York: E. Weyhe, 1930).

29 Pierre Bost, *Photographies modernes* (Paris: Librairie des Arts Décoratifs, [1930]), n.pag., quoted in David Travis, "Kertész and His Contemporaries in Germany and France," in *André Kertész: Of Paris and New York* (Art Institute of Chicago, 1985), p. 85.

30 Carlo Rim, "De l'instantané," *L'Art vivant* 137 (Sept. 1, 1930), repr. and trans. in Phillips (note 27), p. 38, as "On the Snapshot."

31 Brassaï's sleep habits from the 1930s were related to the author by his wife, Gilberte Brassaï.

32 Henry Miller, in an undated (probably 1932) letter to Frank Dobo; photocopy in the files of the Department of Photography, the Art Institute of Chicago.

33 Photocopy in the files of the Department of Photography, the Art Institute of Chicago.

34 Henri Poincaré, *Science and Hypothesis* (New York: Dover Publications, 1952), p. 23.

35 In his introduction to *The Decisive Moment*, Cartier-Bresson mentioned cinematic influences: "'Mysteries of New York,' with Pearl White; the great films of D. W. Griffith—'Broken Blossoms'; the first films of Stroheim; 'Greed'; Eisenstein's 'Potemkin'; and Dreyer's 'Jeanne d'Arc'—these were some of the things that impressed me deeply." He also described seeing a few Atget prints owned by an unnamed photographer.

36 Cartier-Bresson (note 2), p. 42.

37 Irving Penn, in conversation with the author, August 2004 and April 2005. Penn first met Cartier-Bresson in New York City in 1946 and made a portrait of him with his wife. The photograph Cartier-Bresson took of the brothers appeared in "ThePenn Brothers," *Vogue* (Sept. 1, 1962), pp. 186–87.

38 Both the original French and English editions of this book begin with a quote from the *Memoires* of Cardinal de Retz (Jean François de Gondi; 1613–1679): "Il n'y rien en ce monde qui n'ait moment decisive." The whole sentence is not given, but it continues as "et le chef-d'oeuvre de la bonne conduite est de connoître et de prendre ce moment" (There is nothing in this world that is not a decisive moment and the signature of good comportment is knowing and seizing the moment). Thus, the phrase "the decisive moment" has its origins in the seventeenth century. It was not an unusual term with any specific meaning and was common in French writing. In the case of Retz, a link is made to the world at large that resonates with Cartier-Bresson's way of photographing.

39 Two books resulted from Brassaï's many visits with Picasso: Daniel Henry Kahnweiler, *Les Sculptures de Picasso* (Paris: Éditions de Chêne, 1948) and Brassaï, *Conversations avec Picasso* (Paris: Gallimard, 1964).

40 Quoted in Peter Hamilton, *Robert Doisneau: A Photographer's Life* (New York: Abbeville Press, 1995), p. 6.

41 Quoted in ibid., p. 126.

42 Quoted in ibid., p. 234.

43 Ibid., p. 6.

44 Peter Hamilton (ibid., p. 224) stated that it was none other than Robert Giraud who procured the various tradesmen for the French *Vogue* editor.

45 Robert Frank, in *U.S. Camera 1958*, ed. Tom Maloney (New York: U.S. Camera, 1957), p. 115.

46 Yourgrau (note 17), p. 5.

47 Hemingway (note 1), p. 211.

PLATES

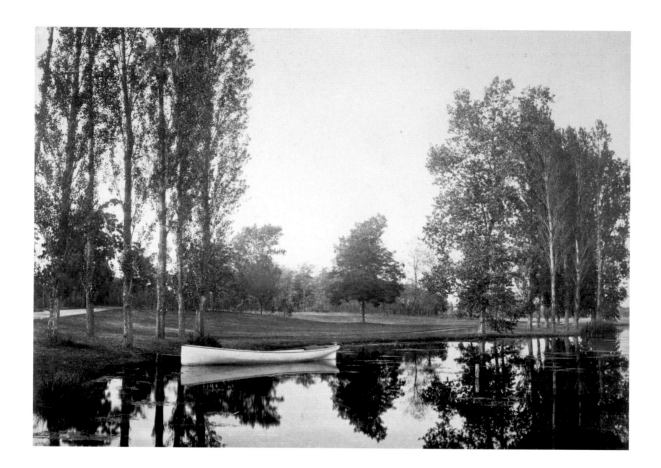

Charles Marville

French, 1816–1879

Untitled (Bois de Boulogne), 1858

∎ ∎ ∎

Albumen print from wet-collodion glass negative; 25.4 x 35.8 cm

Gift of Drs. William and Martha Heinemann-Pieper, 1986.3013

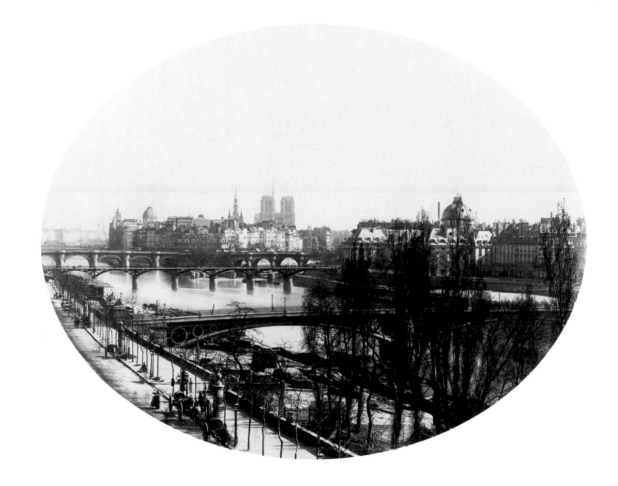

Charles Soulier

French, before 1840–after 1875

Panorama of Paris from the Tuileries, c. 1870

■ ■ ■

Albumen print from wet-collodion glass negative; 19.6 x 24.8 cm

Restricted gift of Mr. and Mrs. Gaylord Donnelley, 1969.566

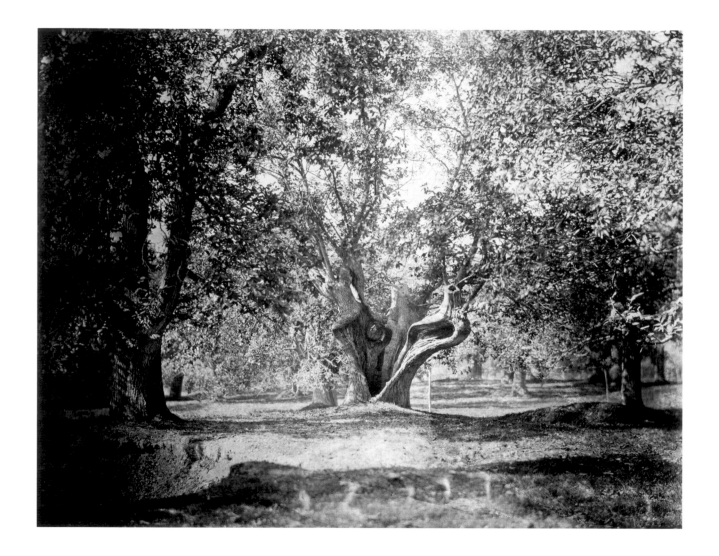

30

Gustave Le Gray

French, 1820–1884

Tree, Fontainebleau Forest, 1855/57

■ ■ ■

Albumen print from wet-collodion glass negative; 31.8 x 41.6 cm

Edward E. Ayer Endowment in memory of Charles L. Hutchinson;

Samuel P. Avery, Wentworth G. Field Memorial, Maurice D. Galleher,

General Acquisitions, and Laura T. Magnuson endowments, 1987.54

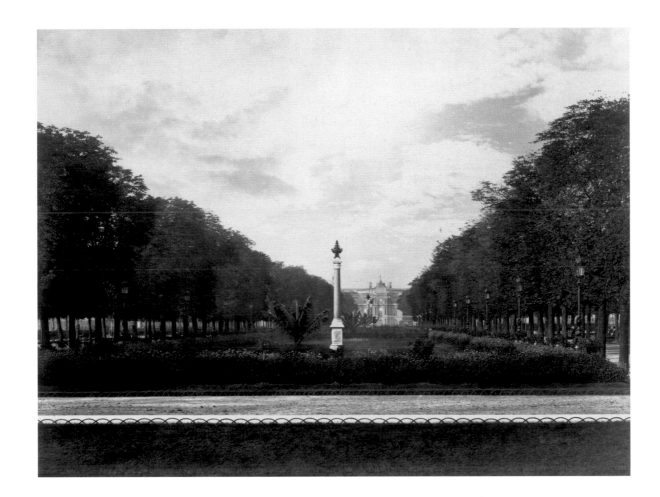

Charles Soulier

Avenue de l'Observatoire, Paris, c. 1870

. . .

Albumen print from wet-collodion glass negative; 18.9 x 25 cm

Restricted gift of Mr. and Mrs. Gaylord Donnelley, 1969.577

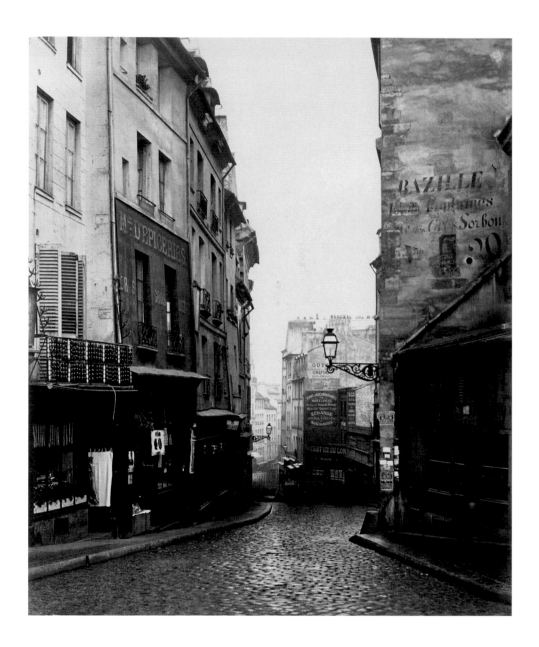

Charles Marville

Rue de la Montagne-Sainte-Geneviève near the Intersection of rue Laplace, 1865/68

■ ■ ■

Albumen print from wet-collodion glass negative; 31.6 x 26.9 cm

Ada Turnbull Hertle Fund, 2003.121

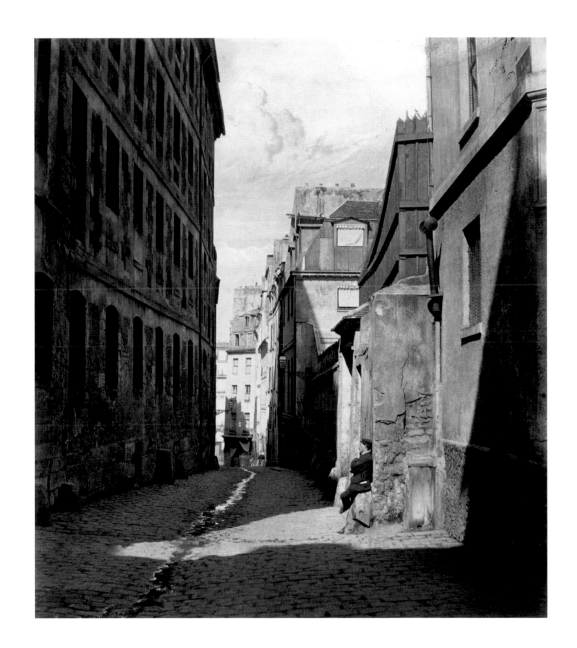

Charles Marville

Rue Chartière (impasse Chartière) of rue de Reims toward rue Saint-Hilaire, 1865/68

■ ■ ■

Albumen print from wet-collodion glass negative; 30.3 x 27 cm

Ada Turnbull Hertle Fund, 2003.120

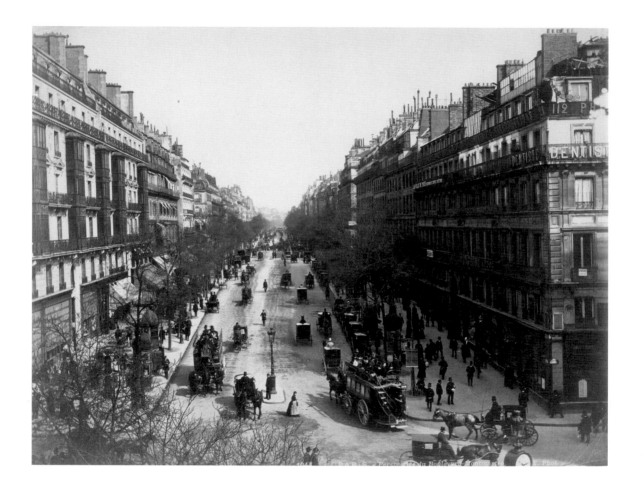

Artist unknown

Paris, Perspective of boulevard Montmartre, 1870/79

■ ■ ■

Albumen print from wet-collodion negative; 20.7 x 27.4 cm

Julien Levy Collection, gift of Jean Levy and the estate of Julien Levy, 1988.157.92

Alfred Stieglitz

American, 1864–1946

Along the Seine, 1894

■ ■ ■

Photogravure; 16.8 x 27.3 cm

Alfred Stieglitz Collection, 1949.842

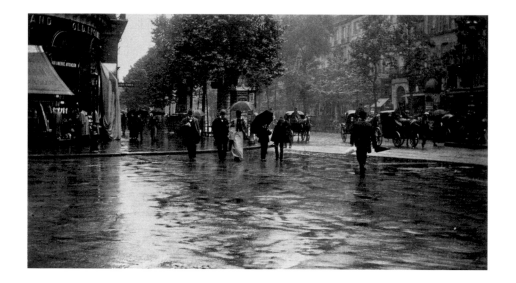

Alfred Stieglitz

A Wet Day on the Boulevard, 1894

■ ■ ■

Carbon print; 9.2 x 16.6 cm

Simeon B. William Endowment, 1993.255

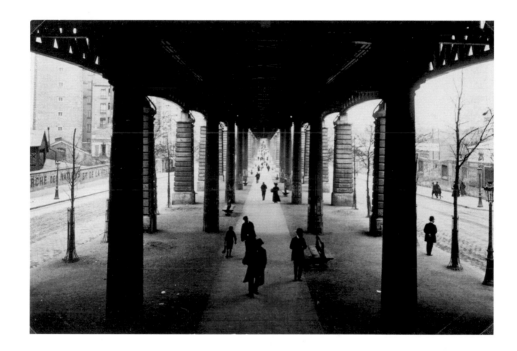

Harry C. Ellis

American, 1857–1928

Under the Metro, Paris, 1905/15

■ ■ ■

Gelatin silver print; 11.5 x 17.3 cm

Restricted gift of Edward Byron Smith, 1987.223

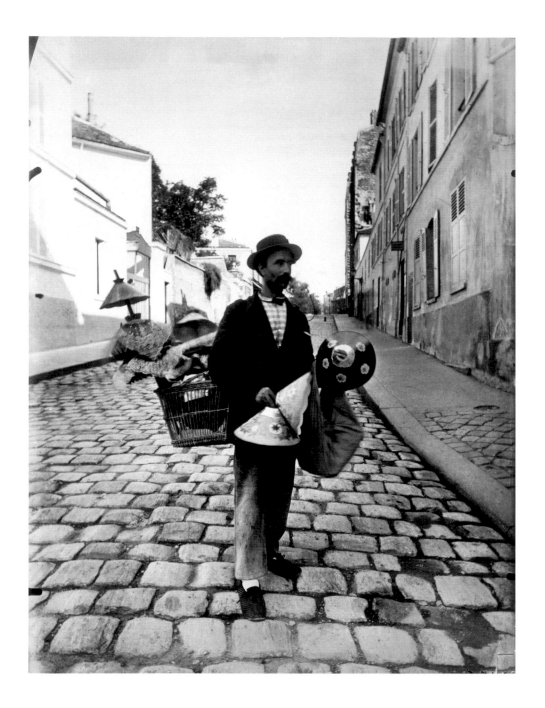

Eugène Atget

French, 1857–1927

Lamp Shade Vendor (Marchand Abat-Jours), 1899/1900

■ ■ ■

Albumen print; 23 x 17.9 cm

Harold L. Stuart Endowment, 1987.378

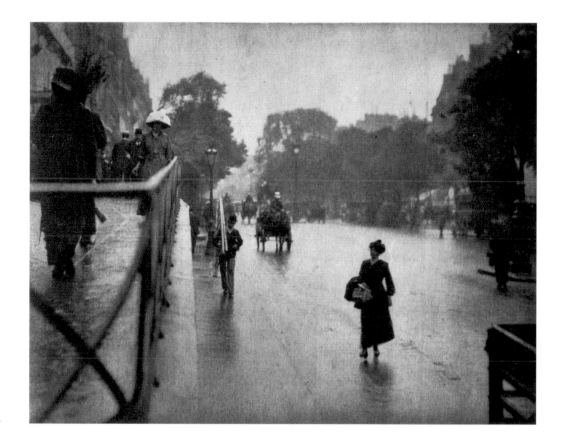

Alfred Stieglitz

A Snapshot, Paris, 1911

■ ■ ■

Photogravure; 13.7 x 17.4 cm

Alfred Stieglitz Collection, Ryerson and Burnham Libraries

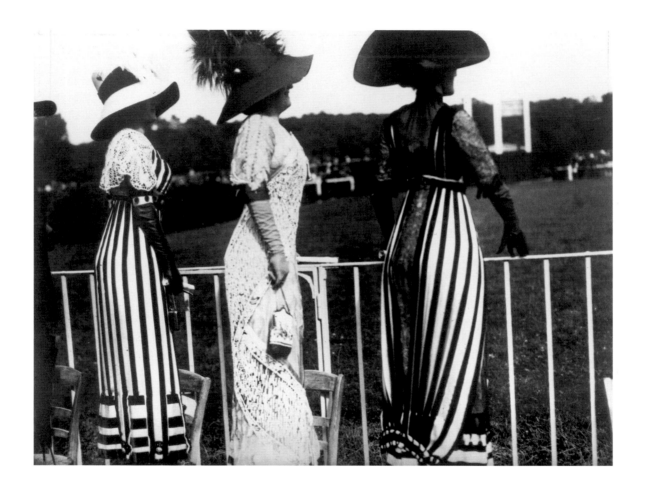

Jacques-Henri Lartigue

French, 1894–1986

The Race Course at Auteuil, Paris, 1910

• • •

Later toned gelatin silver print; 17.2 x 23 cm

Kathleen W. Harvey Memorial Fund, 1974.222.4

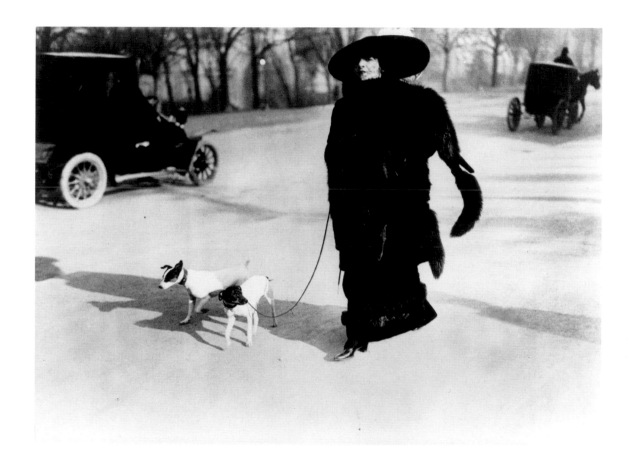

Jacques-Henri Lartigue

Woman with Fox Fur, avenue des Acacias, 1911

∎ ∎ ∎

Later toned gelatin silver print; 16.9 x 23 cm

Kathleen W. Harvey Memorial Fund, 1974.222.5

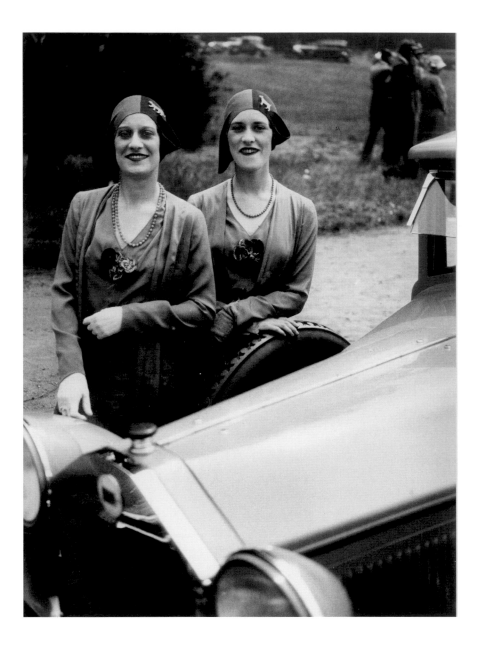

Jacques-Henri Lartigue

The Famous Rowe Twins of the Casino de Paris, 1929

■ ■ ■

Later toned gelatin silver print; 23.1 x 17.2 cm

Kathleen W. Harvey Memorial Fund, 1974.222.9

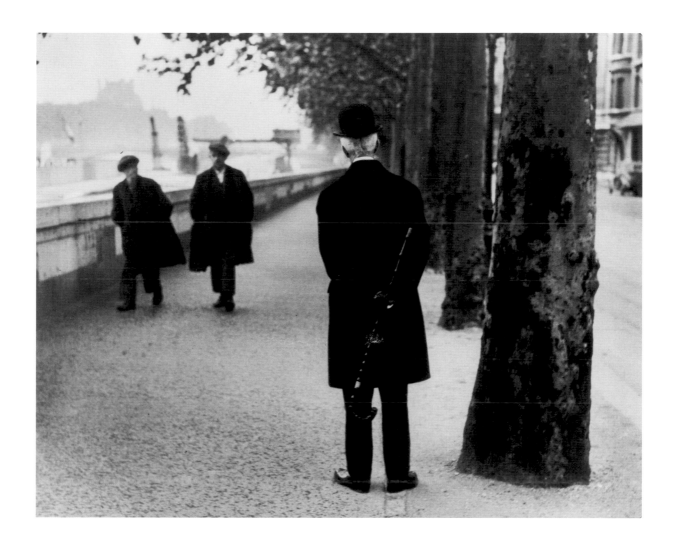

André Kertész

American, born Hungary, 1894–1985

Paris, a Gentleman, 1926

. . .

Later gelatin silver print; 19.7 x 24.7 cm

Gift of Mr. and Mrs. Noel Levine, 1982.1727

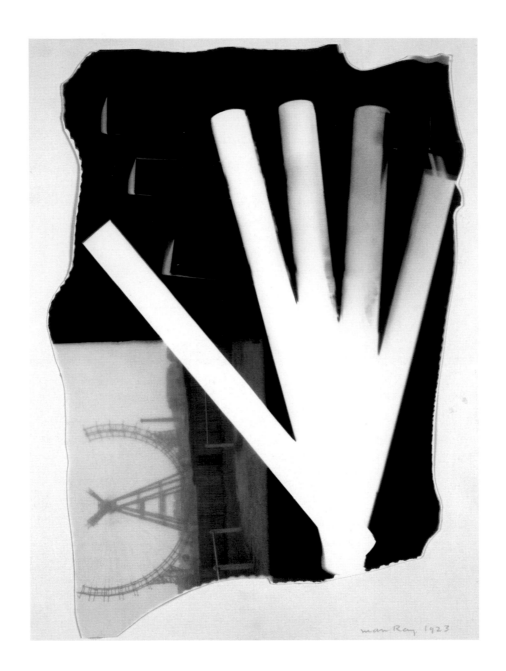

Man Ray

American, 1890–1976

Untitled, 1923

. . .

Gelatin silver print (Rayograph); 24 x 17 cm

Julien Levy Collection, Special Photography Acquisition Fund, 1979.97

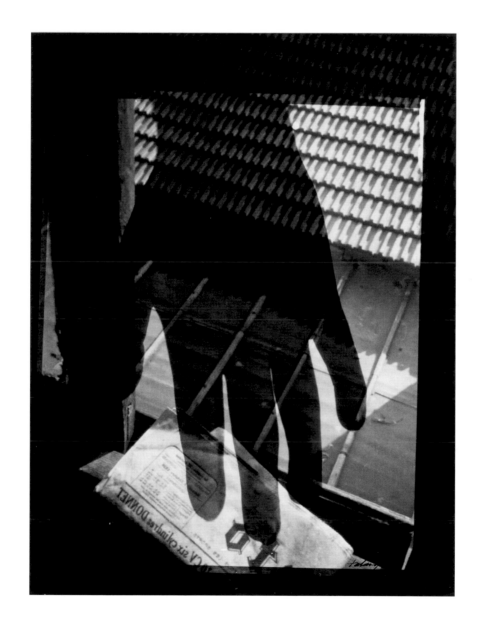

Maurice Tabard

French, 1897–1984

Hand, 1929

▪ ▪ ▪

Gelatin silver print (photomontage of contact prints); 22.9 x 16.5 cm

Julien Levy Collection, gift of Jean and Julien Levy, 1975.1147

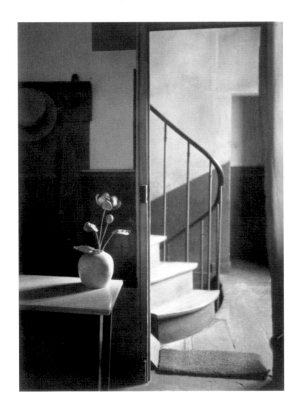

André Kertész

Chez Mondrian, Paris, 1926

. . .

Gelatin silver print on postcard stock; 10.8 x 7.9 cm

Julien Levy Collection, gift of Jean and Julien Levy, 1975.1136

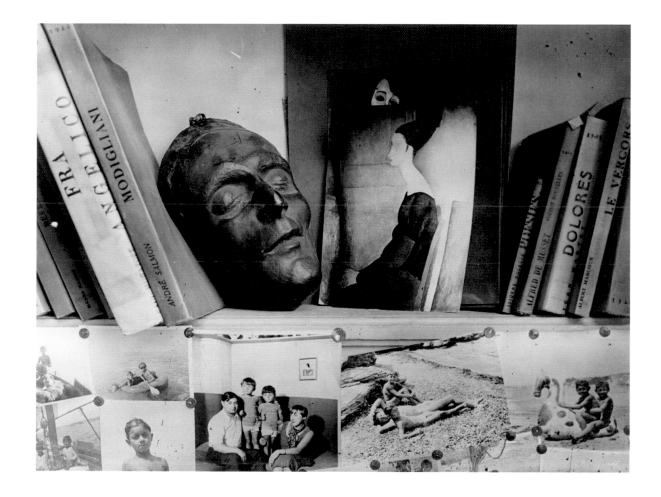

André Kertész

Chez Kisling, Paris, 1933

▪ ▪ ▪

Gelatin silver print; 17.9 x 23.8 cm

Ada Turnbull Hertle and Wirt D. Walker funds, 1984.549

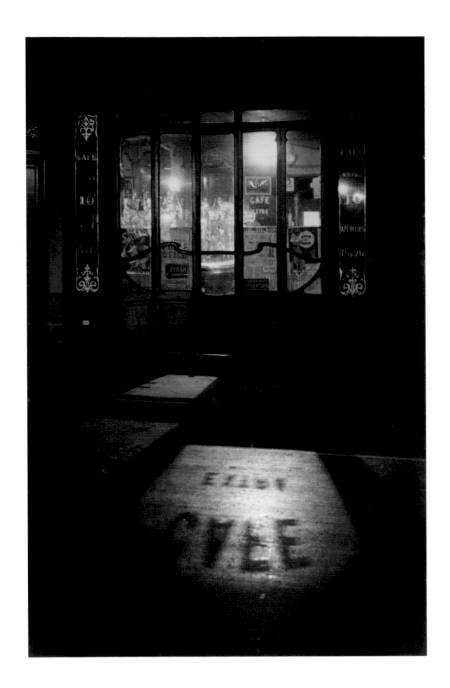

André Kertész

Bistro, Paris, 1927

• • •

Gelatin silver print; 20.1 x 13 cm

Julien Levy Collection, Special Photography Acquisition Fund, 1979.72

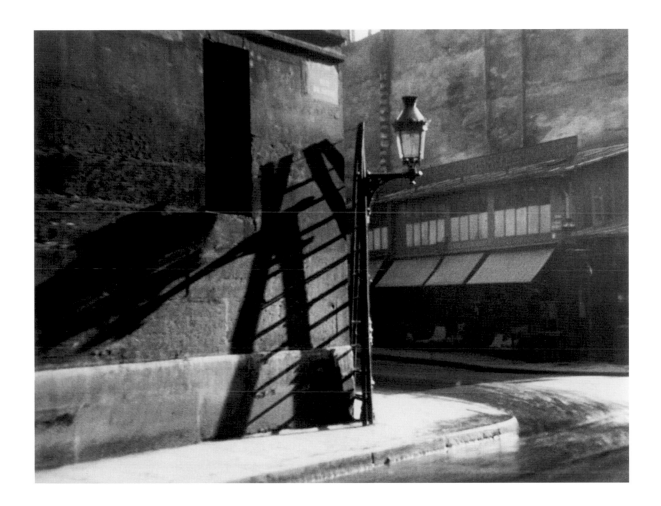

Rogi André

French, born Hungary, 1905–1970

Untitled, 1928

■ ■ ■

Gelatin silver print; 16.6 x 21.9 cm

Julien Levy Collection, gift of Jean and Julien Levy, 1978.1077

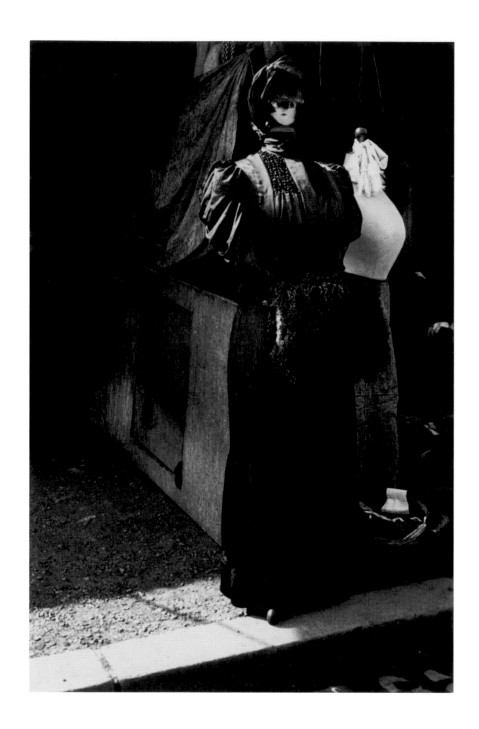

Bill Brandt

English, 1904–1983

Flea Market, Paris, 1929/30

■ ■ ■

Gelatin silver print; 22.7 x 15 cm

The Sandor Family Collection in honor of The School of the Art Institute of Chicago, 1994.696

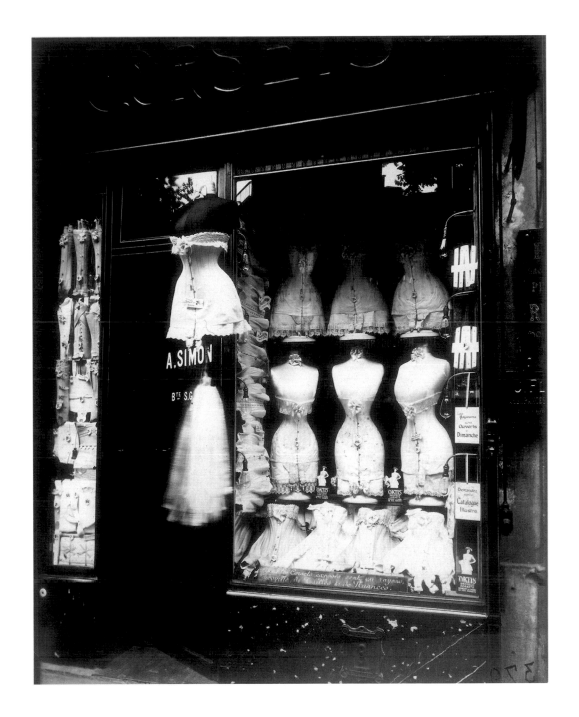

Eugène Atget

Boulevard de Strasbourg (Corsets), 1912

■ ■ ■

Gelatin silver printing-out-paper print from dry plate negative; 22.9 x 18 cm

Julien Levy Collection, gift of Jean and Julien Levy, 1975.1130

Lee Miller

American, 1907–1977

Untitled, 1930

■ ■ ■

Gelatin silver print; 19.5 x 17 cm

Julien Levy Collection, gift of Jean Levy and the estate of Julien Levy, 1988.157.55

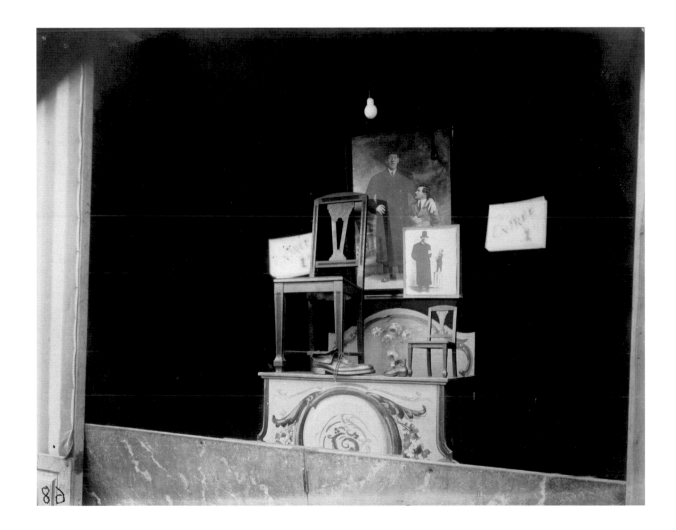

Eugène Atget

Fête du Trône, 1925

∎ ∎ ∎

Gelatin silver printing-out-paper print from dry plate negative; 17.9 x 22.5 cm

Julien Levy Collection, Special Photography Acquisition Fund, 1979.56

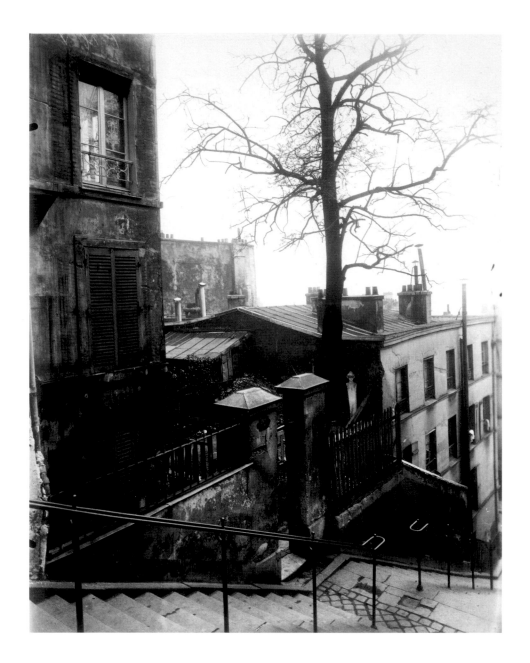

54

Eugène Atget

Montmartre, 2 rue de Calvaire, 1921

■ ■ ■

Albumen print from dry plate negative; 21.5 x 17 cm

Wirt D. Walker Fund and Laura T. Magnuson Endowment, 1980.350

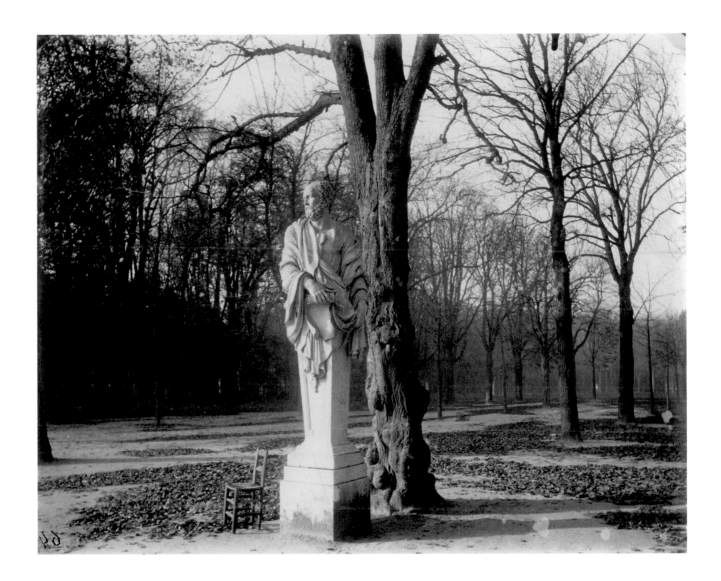

Eugène Atget

Versailles—Corner of the Park, 1904

■ ■ ■

Albumen print from dry plate negative; 17.8 x 21.9 cm

Gift of Mrs. Everett Kovler, 1963.934

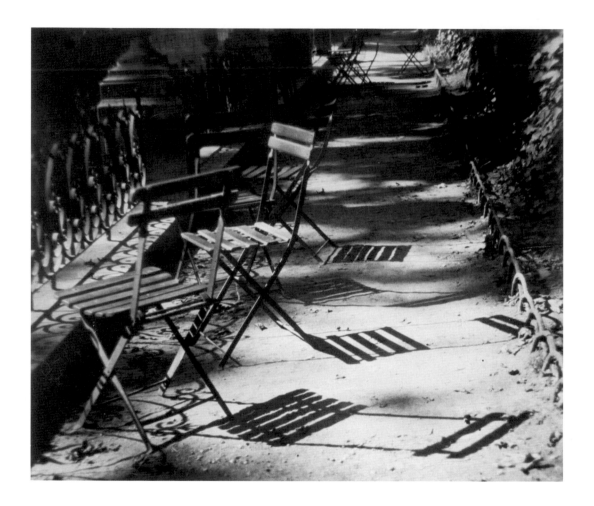

André Kertész

Chairs, the Medici Fountain, Paris, 1926

▪ ▪ ▪

Gelatin silver print; 15.7 x 18.6 cm

Wirt D. Walker Fund, 1984.536

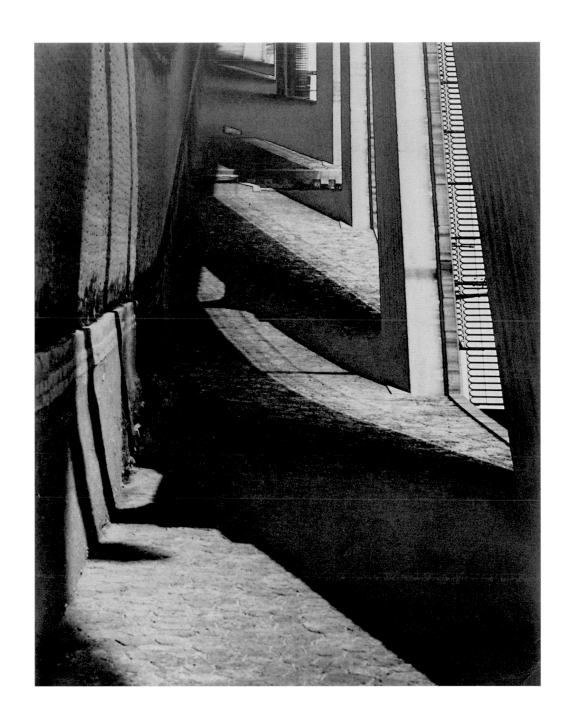

Lee Miller

Untitled, c. 1930

▪ ▪ ▪

Brown-toned gelatin silver print from solarized negative; 34.5 x 27.4 cm

Julien Levy Collection, gift of Jean Levy and the estate of Julien Levy, 1988.157.57

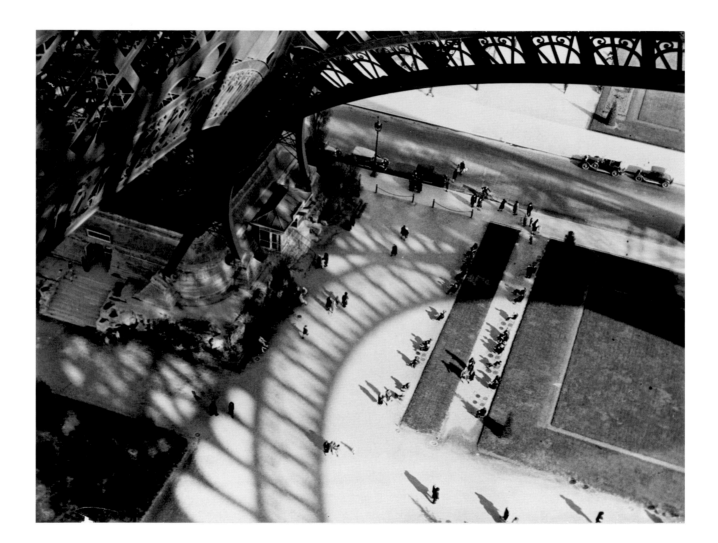

André Kertész

Shadows of the Eiffel Tower, 1929

▪ ▪ ▪

Gelatin silver print; 16.5 x 21.9 cm

Julien Levy Collection, Special Photography Acquisition Fund, 1979.77

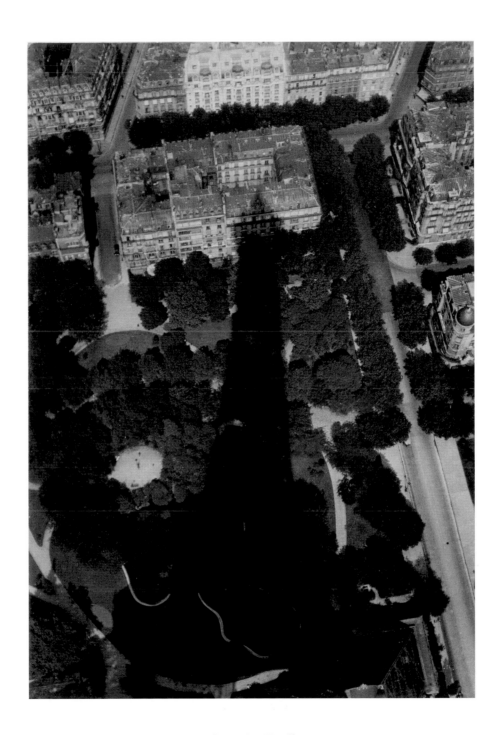

Germaine Krull

French, born Poland, 1897–1985

Paris, 1925/27

▪ ▪ ▪

Gelatin silver print, 22.2 x 15.3 cm

Photography Collection Purchase Fund, 1984.1202

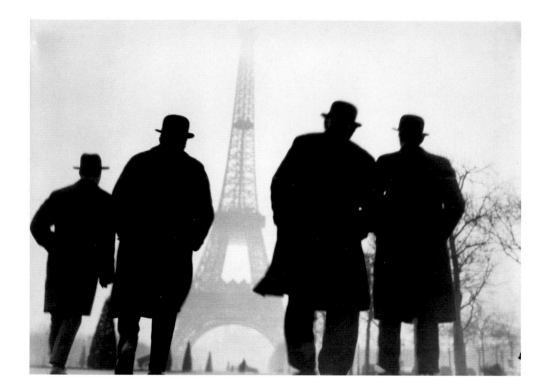

Else Thalemann

German, 1901–1984

Eiffel Tower, Paris, c. 1930

■ ■ ■

Gelatin silver print; 12.6 x 17.7 cm

Restricted gift of Helen Harvey Mills, 1986.153

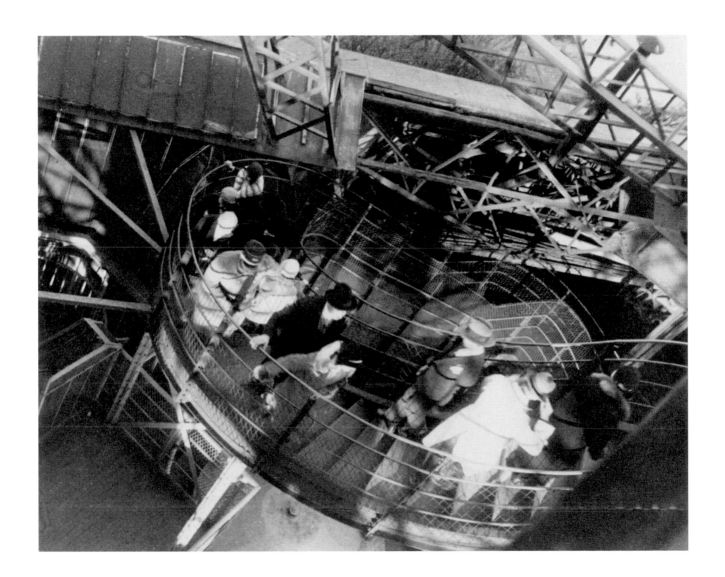

Ilse Bing

American, born Germany, 1899–1998

Untitled, 1931

■ ■ ■

Gelatin silver print; 22.2 x 28.2 cm

Julien Levy Collection, gift of Jean and Julien Levy, 1977.195

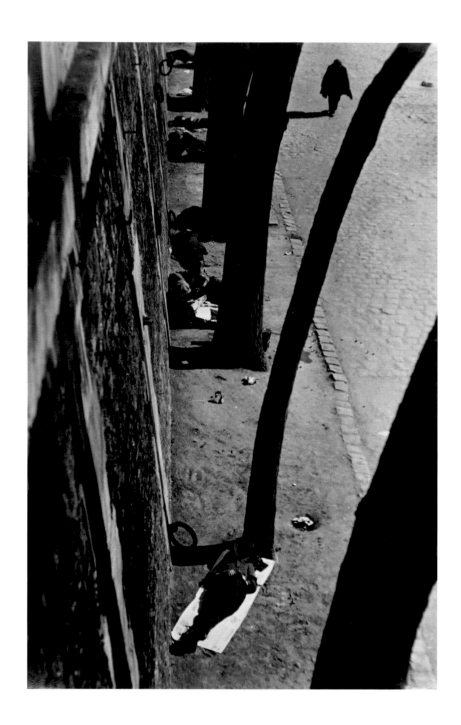

André Kertész

Siesta, Paris (View from the Pont au Change), 1927

■ ■ ■

Gelatin silver print; 23.9 x 15.6 cm

Julien Levy Collection, Special Photography Acquisition Fund, 1979.80

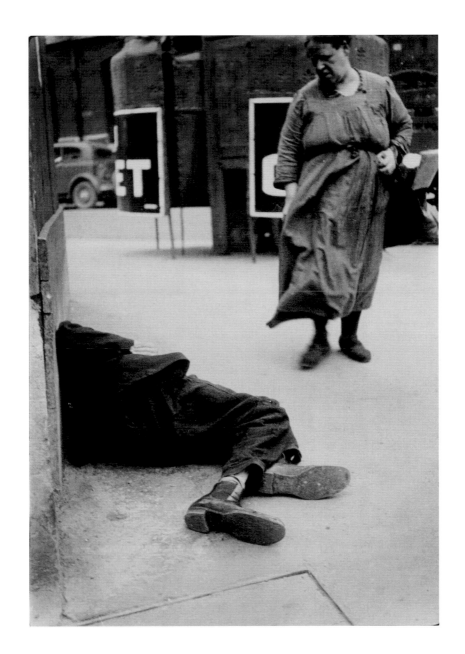

Henri Cartier-Bresson

French, 1908–2004

La Villette, Paris, 1929

. . .

Gelatin silver print; 23.1 x 16.1 cm

Julien Levy Collection, gift of Jean and Julien Levy, 1978.1058

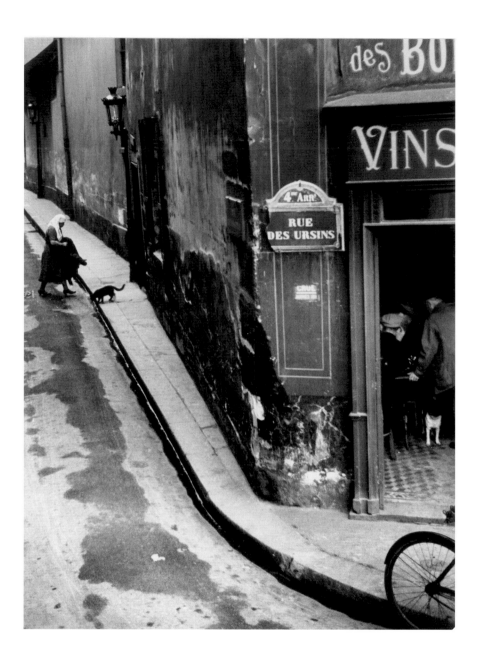

André Kertész

Paris, rue des Ursins, 1931

. . .

Later gelatin silver print; 24.7 x 18.2 cm

Gift of Mr. and Mrs. Noel Levine, 1982.1744

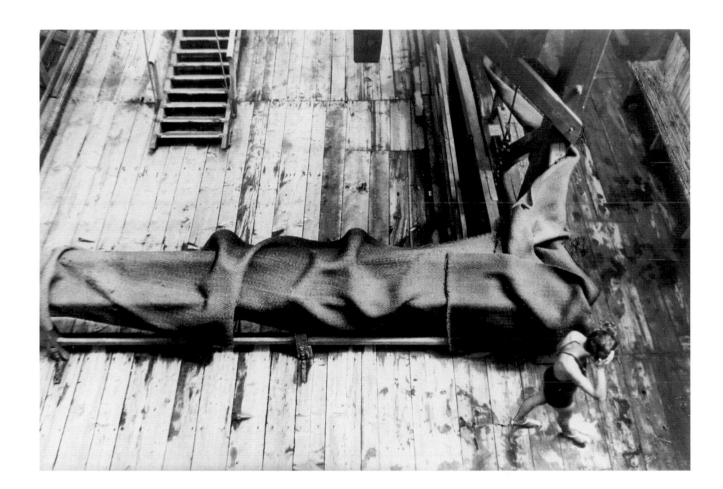

Henri Cartier-Bresson

Paris, 1932/33

▪ ▪ ▪

Gelatin silver print; 19.6 x 29.3 cm

Julien Levy Collection, gift of Jean and Julien Levy, 1978.1053

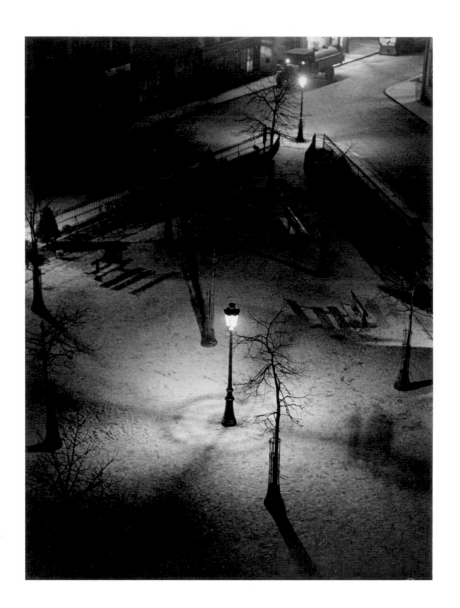

André Kertész

Montparnasse, Square Jolivet, 1929

■ ■ ■

Gelatin silver print; 21.4 x 16 cm

Harold L. Stuart Endowment, 1987.376

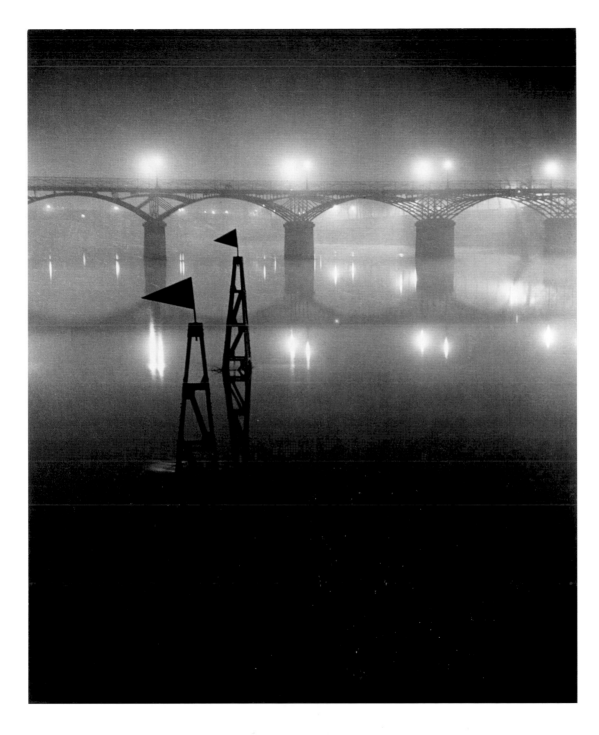

Brassaï (Gyula Halász)

French, born Transylvania, 1899–1984

Pont des Arts in Fog, 1934

▪ ▪ ▪

Gelatin silver print; 49.4 x 40.1 cm

Peabody Fund, 1955.26

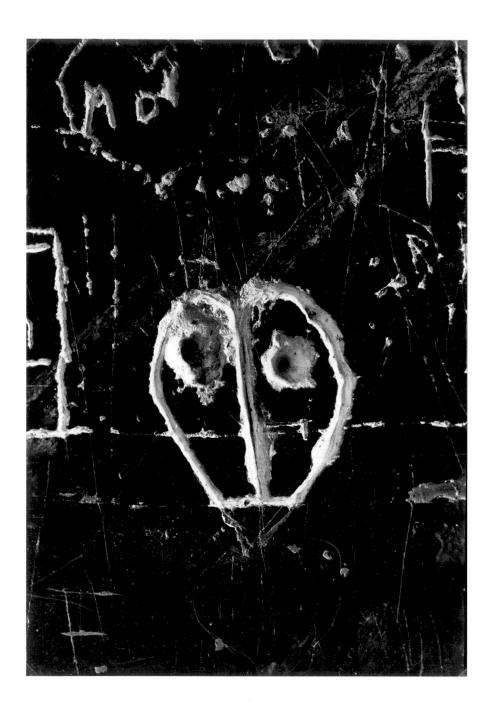

Brassaï

Graffiti Heart (Coeur No. 2), 1940

■ ■ ■

Gelatin silver print; 27 x 18.6 cm

Mary and Leigh Block Endowment, 1998.157

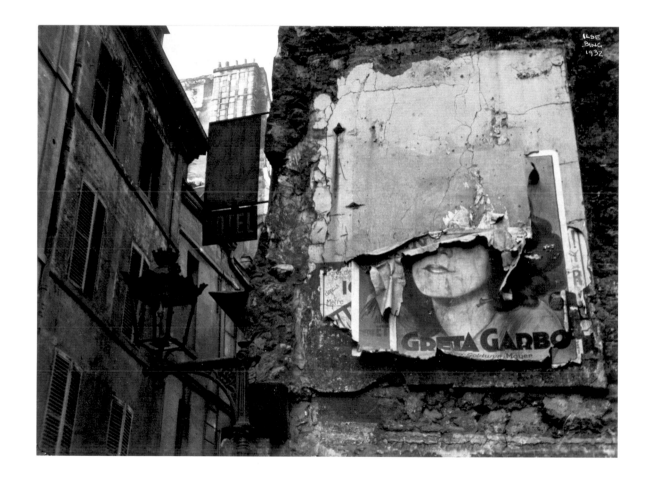

Ilse Bing

Greta Garbo Poster, Paris, 1932

■ ■ ■

Later gelatin silver print; 16.8 x 23 cm

Gift of David C. and Sarajean Ruttenberg, 1991.1283

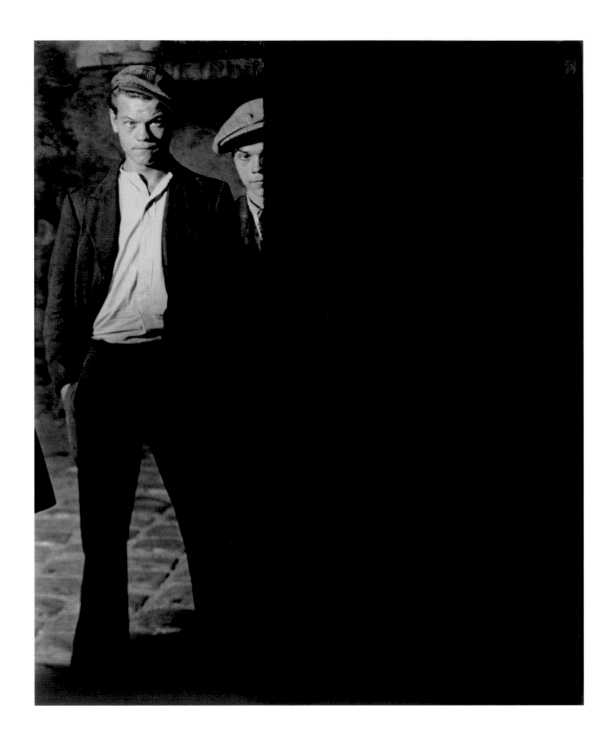

70

Brassaï

Two Apaches in Paris, 1931/32

■ ■ ■

Gelatin silver print; 49.2 x 40.4 cm

Peabody Fund, 1955.23

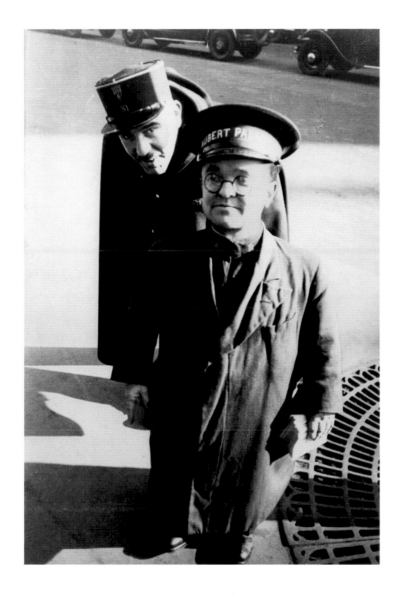

Henri Cartier-Bresson

Paris, 1932/33

∎ ∎ ∎

Gelatin silver print; 29.6 x 19.9 cm

Julien Levy Collection, gift of Jean and Julien Levy, 1978.1051

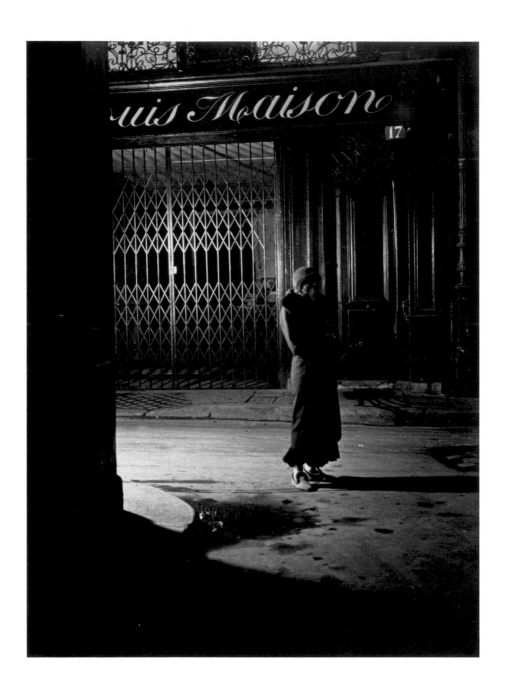

Brassaï

Untitled, 1932

■ ■ ■

Gelatin silver print; 23.3 x 17.3 cm

Restricted gift of Leigh B. Block, 1983.55

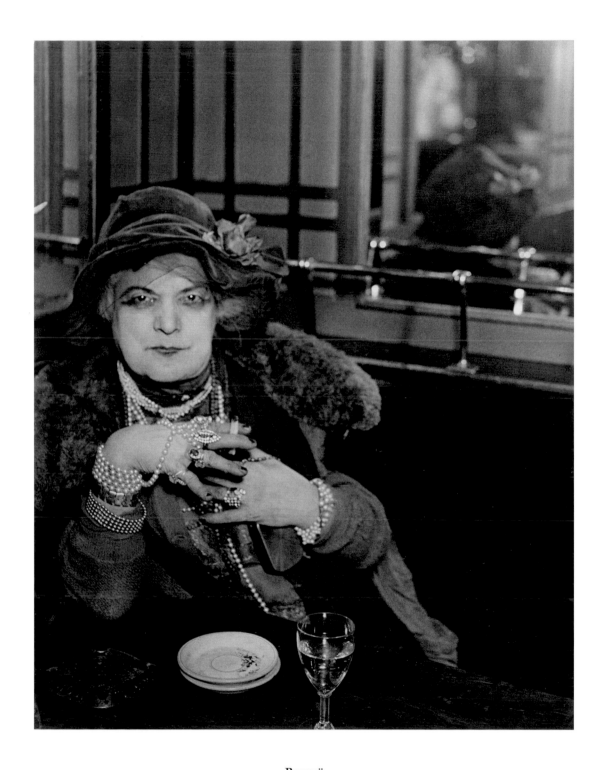

Brassaï

Bijou at the Bar de la Lune, Montmartre, 1932

■ ■ ■

Gelatin silver print; 50.5 x 40 cm

Peabody Fund, 1955.22

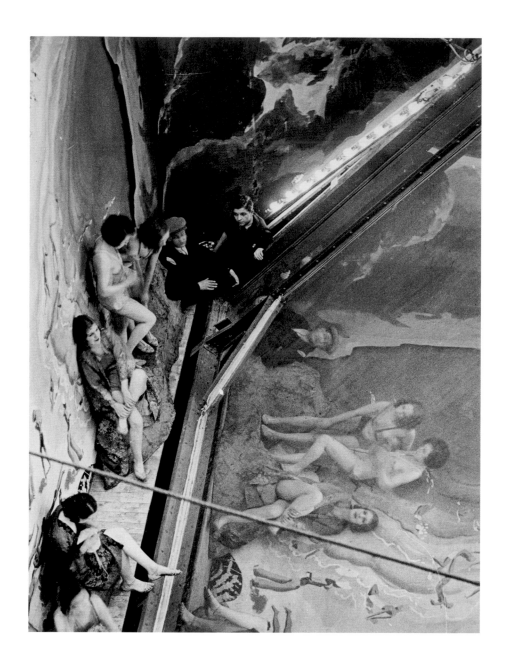

Brassaï

Backstage at the Folies Bergère, 1932

■ ■ ■

Gelatin silver print; 23.5 x 17.8 cm

Restricted gift of Leigh B. Block, 1983.56

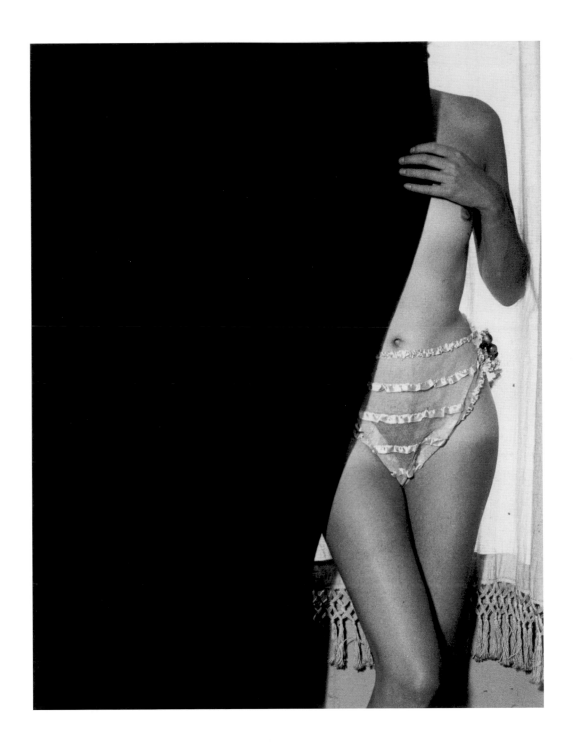

Brassaï

Ballet Rose, 1932

■ ■ ■

Gelatin silver print; 29.4 x 22.5 cm

Restricted gift of Exchange National Bank of Chicago, 1974.368

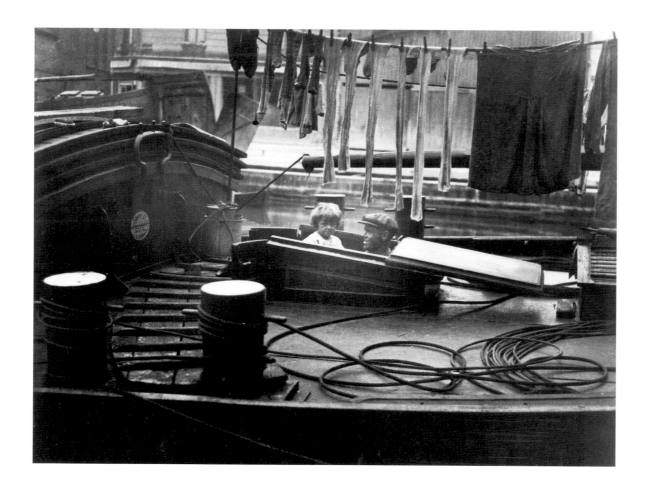

Brassaï

Untitled, 1931

. . .

Gelatin silver print; 17.7 x 23.5 cm

Gift of M. and Mme. Brassaï, 1990.376

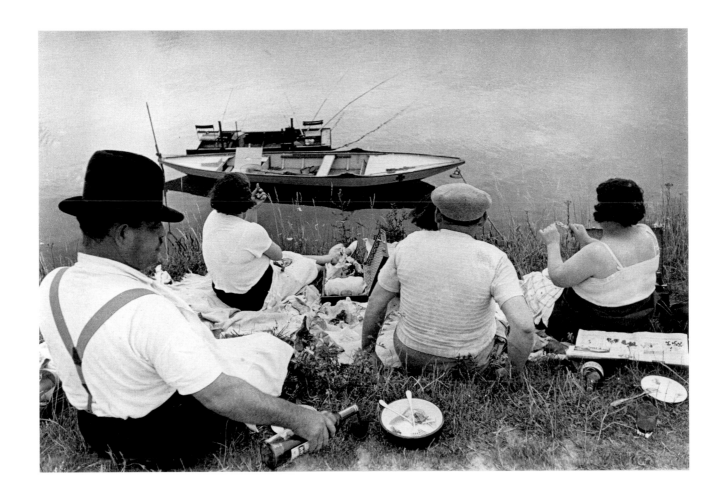

Henri Cartier-Bresson

Sunday on the Banks of the Marne, 1938

■ ■ ■

Gelatin silver print; 23.9 x 35.4 cm

Publicity Department Photography Sundry Account, 1954.185

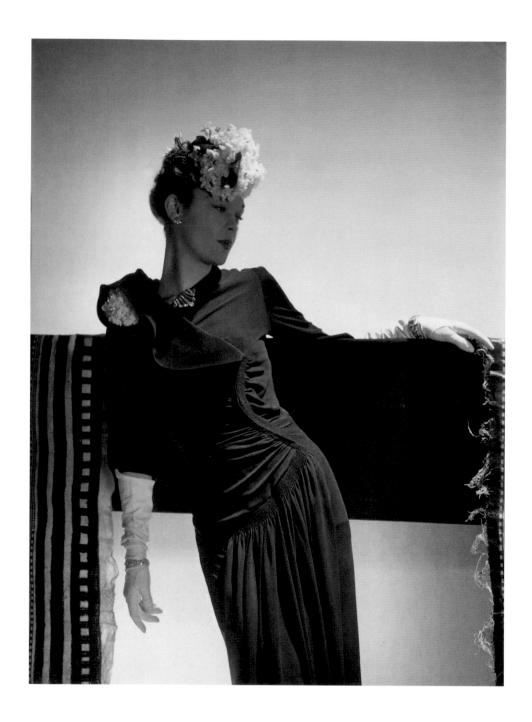

78

Horst P. Horst

American, born Germany, 1906–1999

Daquin, bijoux Boucheron, Studio Horst, Paris, 1938

■ ■ ■

Gelatin silver print; 23.1 x 16.8 cm

Restricted gift of Helen Harvey Mills in memory of Kathleen Whitcomb Harvey, 2001.57

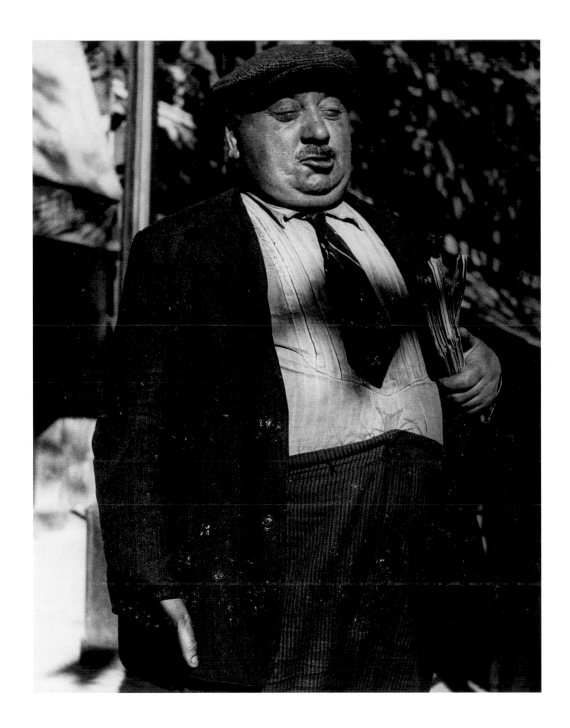

Lisette Model

American, born Austria, 1906–1983

Man with Pamphlets, Paris, 1938

. . .

Gelatin silver print; 34.5 x 28 cm

Gift of Boardroom, Inc., 1992.703

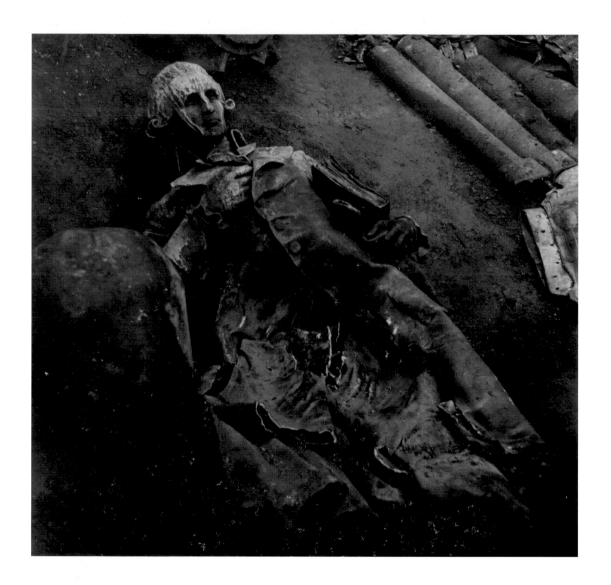

Pierre Jahan

French, 1909–2003

Condorcet, 1942/43

■ ■ ■

Gelatin silver print; 17.9 x 18.8 cm

Restricted gift of John A. Bross in memory of Edward Byron Smith, 2005.55

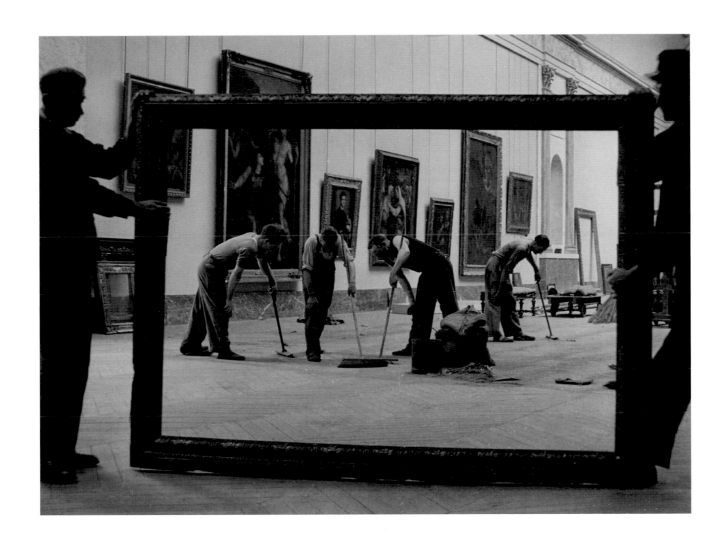

Pierre Jahan

Paintings Return to the Louvre, 1945

■ ■ ■

Gelatin silver print; 27 x 37.2 cm

Restricted gift of Karen and Jim Frank, 2005.56

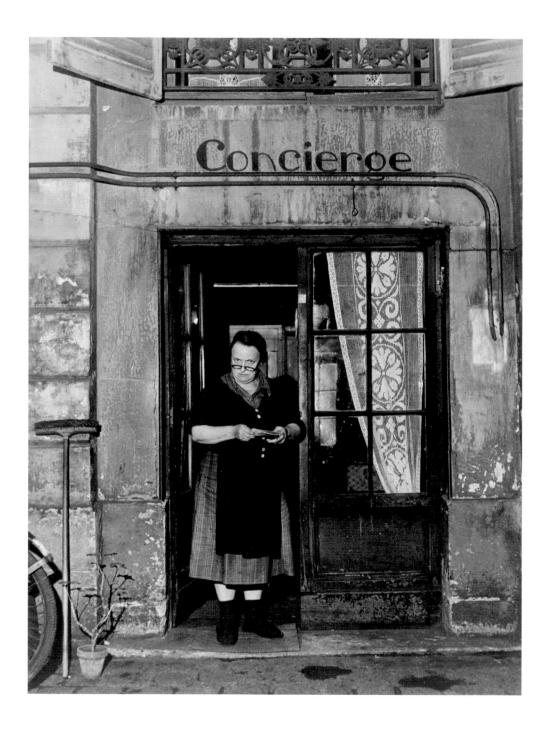

Robert Doisneau

French, 1912–1994

Concierge, rue Jacob, Paris, Sixth Arrondissement, 1945

■ ■ ■

Gelatin silver print; 39.1 x 29.7 cm

Peabody Fund, 1954.1240

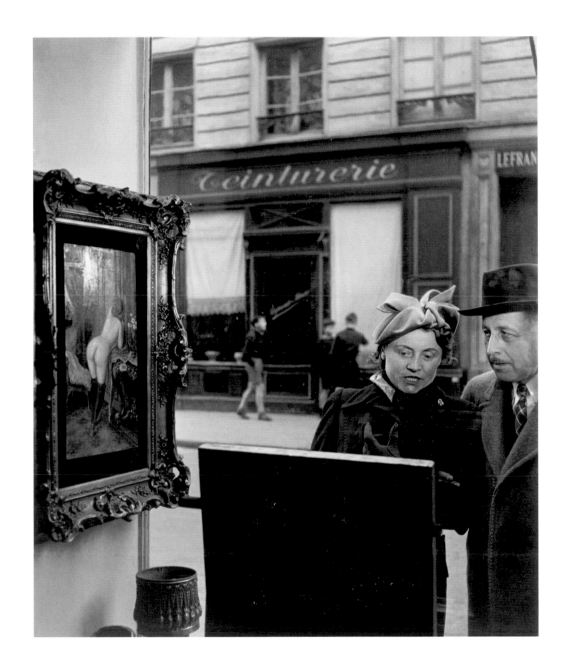

Robert Doisneau

Sidelong Glance (Le Regard oblique), Paris, Sixth Arrondissement, 1948

. . .

Gelatin silver print; 35 x 29 cm

Peabody Fund, 1954.1238

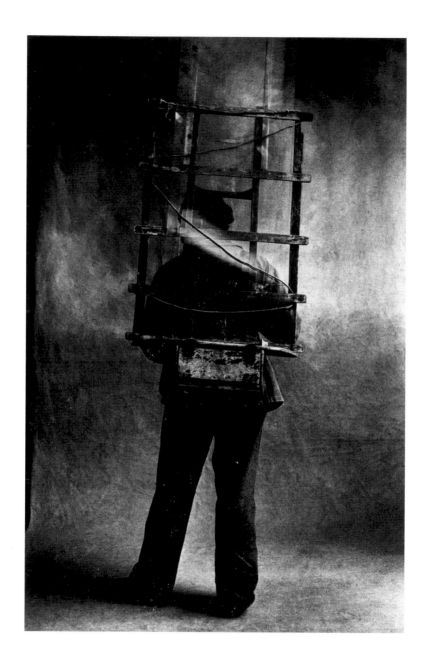

Irving Penn

American, born 1917

Vitrier (Glazier), Paris, 1950

. . .

Later platinum-palladium print; 42.9 x 27.6 cm

Gift of Irving Penn, 1996.265

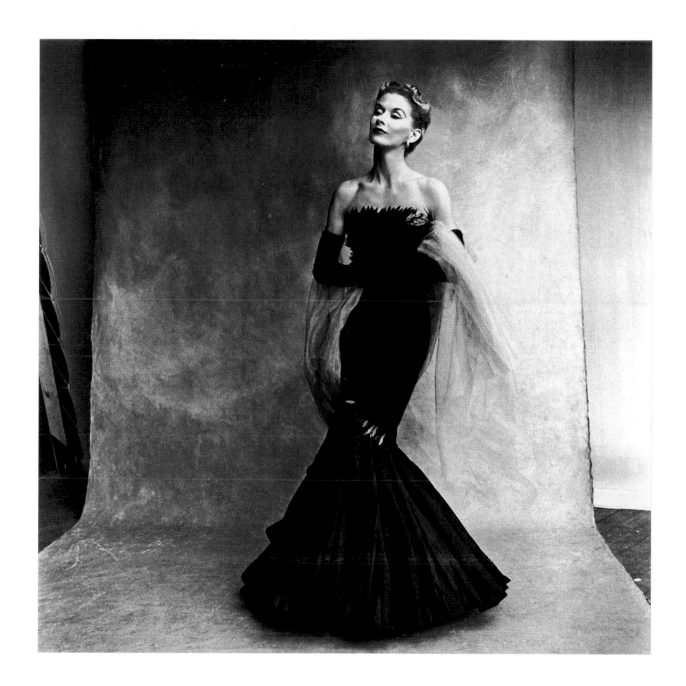

Irving Penn

Rochas Mermaid Dress (Lisa Fonssagrives-Penn), Paris, 1950

■ ■ ■

Later platinum-palladium print; 49.5 x 49.5 cm

Gift of Irving Penn, 1996.237

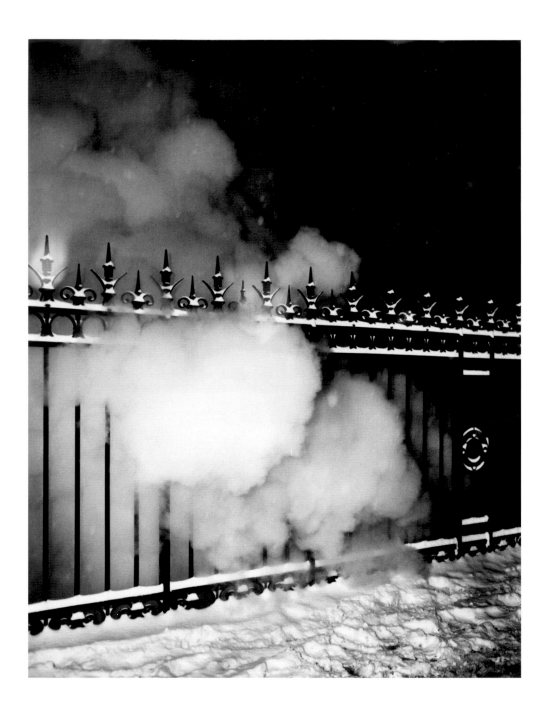

René-Jacques

French, 1908–2003

Saint-Lazare Station, 1947

. . .

Gelatin silver print; 36.6 x 28.7 cm

Ernest N. Kahn Endowment, 1987.359

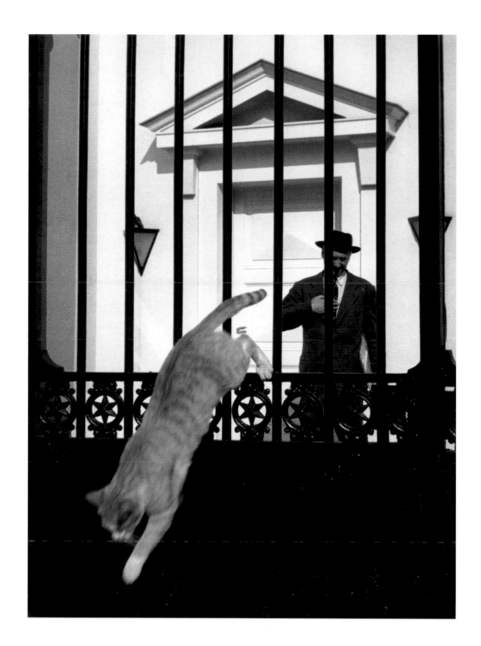

Sabine Weiss

French, born 1924

Félix Labisse, c. 1954

. . .

Gelatin silver print; 34.9 x 26 cm

Peabody Fund, 1954.1221

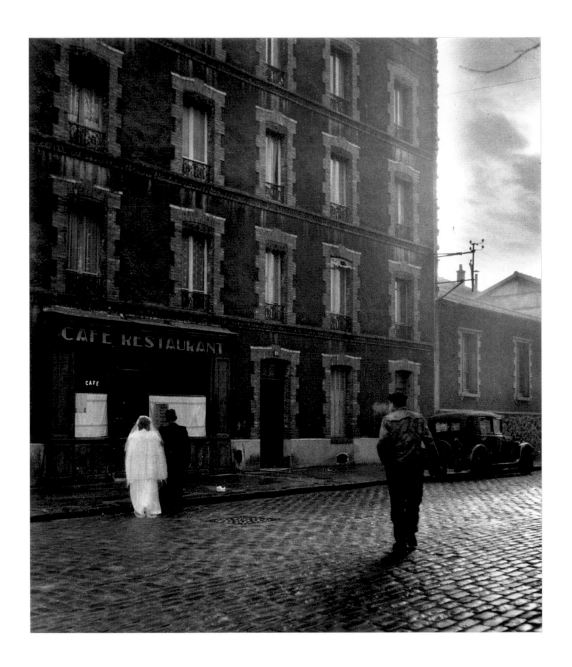

Robert Doisneau

In the Strictest Intimacy (La Stricte Intimité),
rue Marcelin Berthelot, Montrouge, 1945

■ ■ ■

Later gelatin silver print; 28.3 x 24.5 cm

Gift of Elizabeth and Frederick Myers, 1983.1531

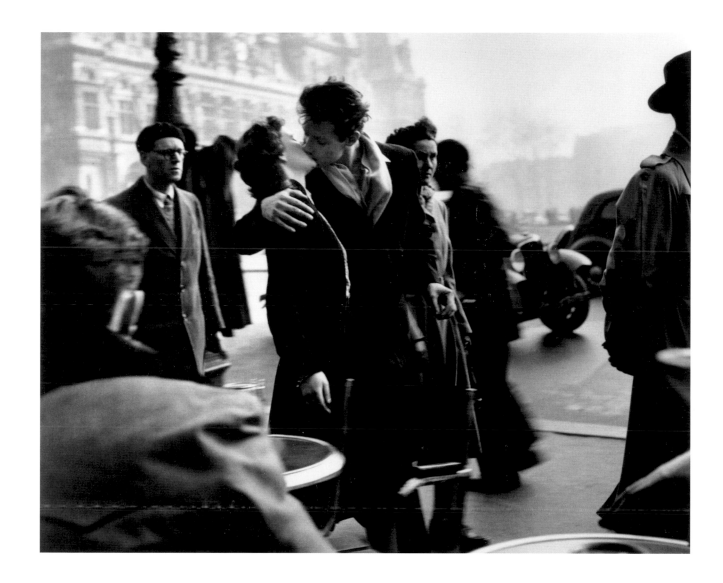

Robert Doisneau

Kiss at the Hôtel de Ville (*Le Baiser de l'Hôtel de Ville*), 1950

■ ■ ■

Later gelatin silver print; 24.4 x 30.6 cm

Gift of Elizabeth and Frederick Myers, 1983.1530

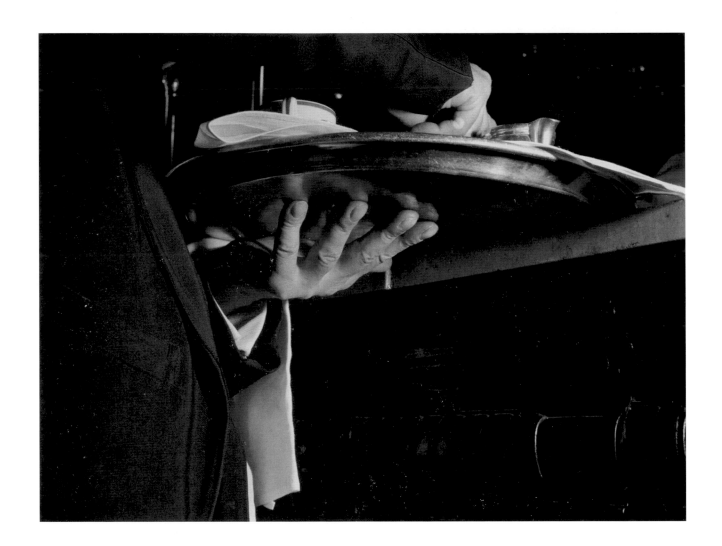

Pierre Jahan

Waiter at the Brasserie Lipp, c. 1950

■ ■ ■

Gelatin silver print; 30 x 39.8 cm

Restricted gift of Robert and Doris Taub, 2005.57

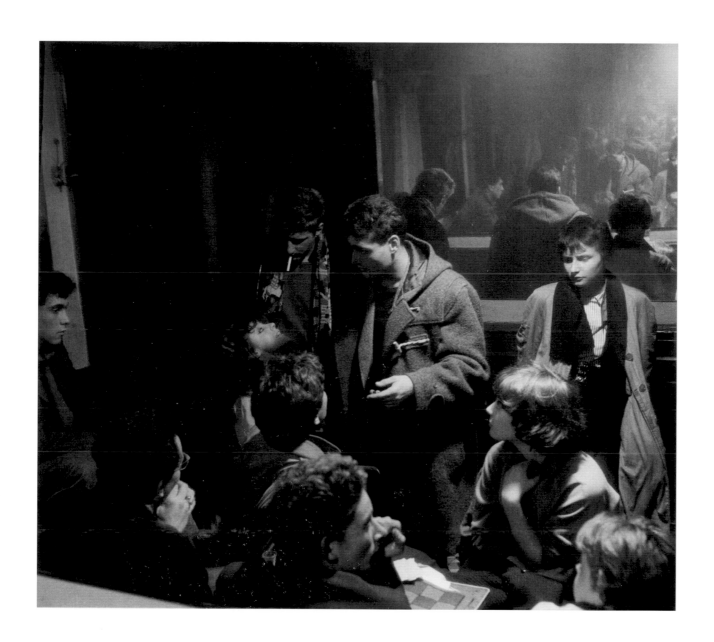

Ed Van der Elsken

Dutch, 1925–1990

Benny and Joe Flirt with Ann, c. 1956

∎ ∎ ∎

Gelatin silver print; 29.5 x 33.4 cm

Peabody Fund, 1957.208

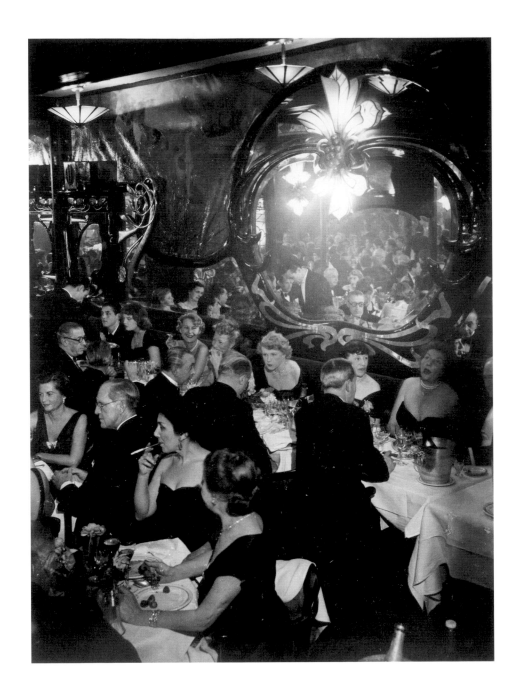

Brassaï

A Gala at Maxim's, 1949

. . .

Gelatin silver print; 32.7 x 24.1 cm

Restricted gift of Harold Joachim in memory of Kathleen W. Harvey, 1974.221

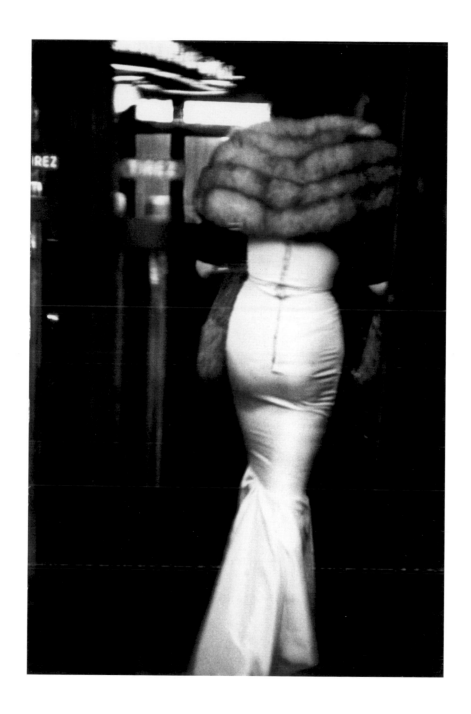

Robert Frank

American, born Switzerland 1924

Paris, 1952

■ ■ ■

Gelatin silver print; 34.2 x 22.5 cm

Maurice D. Galleher Endowment, 1992.789

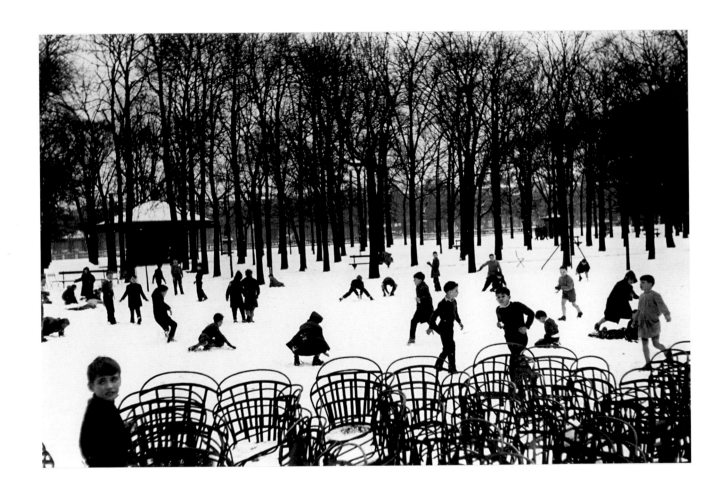

Edouard Boubat

French, 1923–1999

Children in the First Snow, Paris, 1955

■ ■ ■

Gelatin silver print; 23.7 x 35.7 cm

Gift of Elizabeth and Frederick Myers, 1983.1510

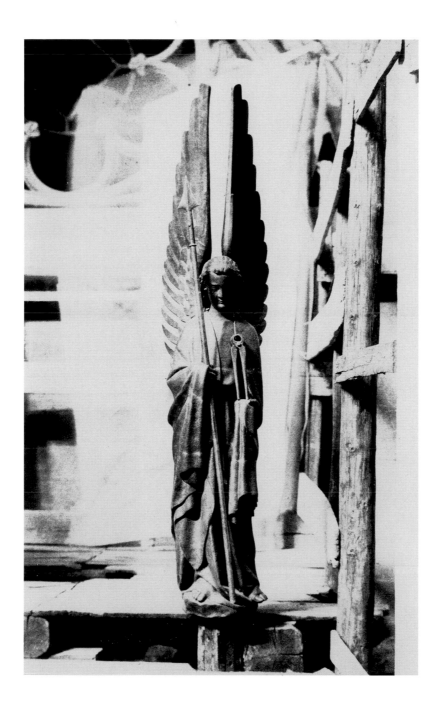

O. Mestral

French, active 1850s

Angel, Sainte-Chapelle, 1851

. . .

Salted paper print from a paper negative; 33.5 x 20.8 cm

Restricted gift of Anstiss and Ronald Krueck in honor of Dr. Paul Urnes, 2001.60

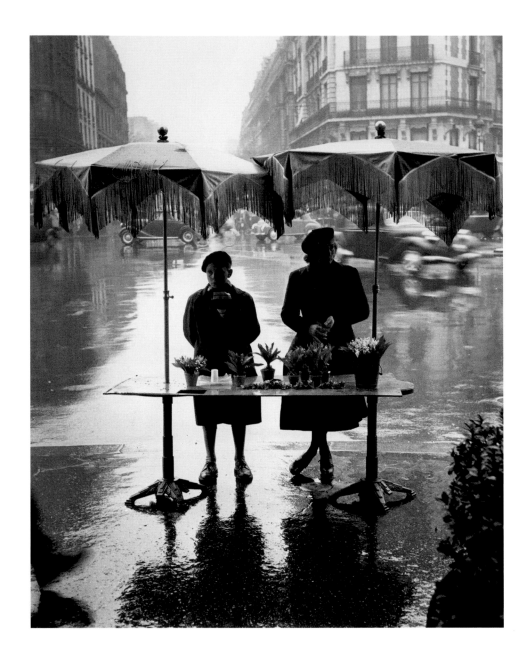

Izis (Bidermanas)

French, born Lithuania, 1911–1980

May 1, place Victor Basch, 1950

. . .

Gelatin silver print; 27.3 x 22.1 cm

Peabody Fund, 1955.756

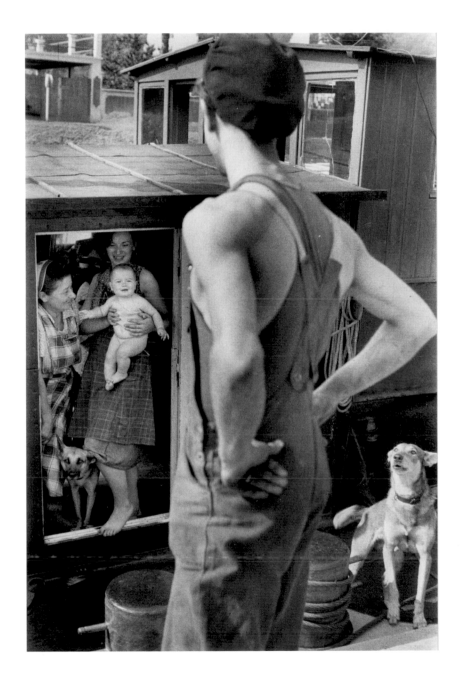

Henri Cartier-Bresson

Bargeman of the Seine, 1957

■ ■ ■

Gelatin silver print; 29.4 x 19.5 cm

Photography Gallery Restricted Gift Fund, 1962.178

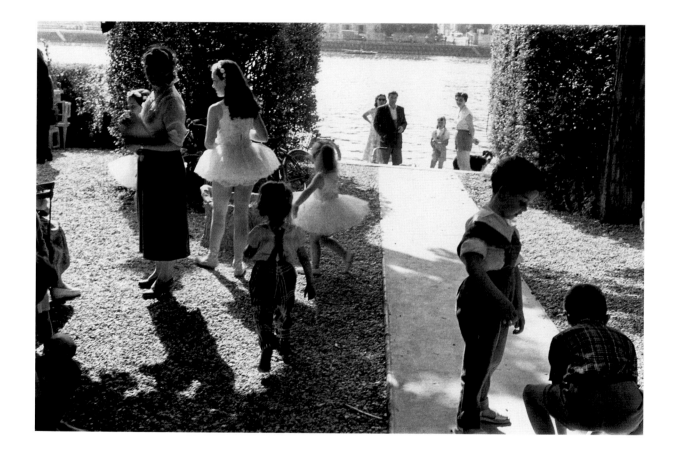

Henri Cartier-Bresson

Children's Party along the Seine, 1956

∎ ∎ ∎

Gelatin silver print; 19.7 x 29.5 cm

Photography Gallery Restricted Gift Fund, 1962.184

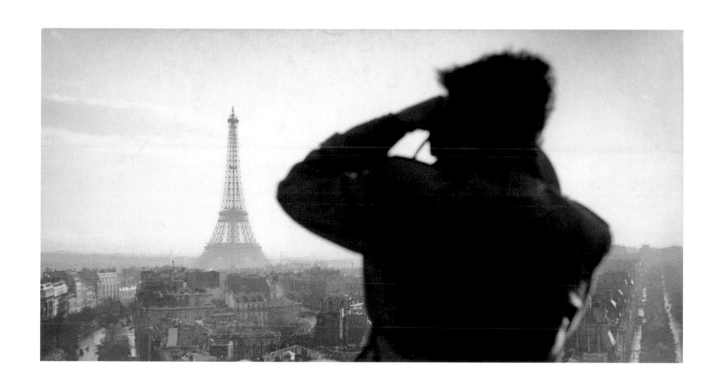

Robert Frank

Self-Portrait, Paris, 1949/51

■ ■ ■

Gelatin silver print; 17.8 x 34.3 cm

Maurice D. Galleher Endowment, 1992.791

COLOPHON

Produced by the Publications Department of the Art Institute of Chicago, Susan F. Rossen, Executive Director

Edited by Katherine E. Reilly, Assistant Editor, Scholarly Publications

Production by Amanda W. Freymann, Associate Director of Publications—Production

Rights clearance by Sarah K. Hoadley, Photo Editor

Designed and typeset by Nicole M. Eckenrode, Department of Graphic Design, Photographic, and Communication Services

Sequencing by David Travis

Separations, printing, and binding by Amilcare Pizzi S.p.A.

■ ■ ■

The typefaces chosen for this book reflect a style of display and text fonts set for *Arts et métiers graphiques*, a deluxe publication on typography and the graphic arts established in 1927 by the publisher-printer-typefounder Charles Peignot.

Sphinx, the display face, was the first face commissioned by Peignot's company Deberny et Peignot in 1924 when it decided to update its display fonts, which previously had a classical or Art Nouveau character. It appeared in the firm's catalogue the next year and in the first issue of *Arts et métiers graphiques*. Our version is from Monotype.

Galliard, the text face, is based on a sixteenth-century design by the great French punch cutter Robert Granjon. The version used here, ITC Galliard, is a 1978 revival created by Matthew Carter for the firm Mergenthaler. Although this is not the exact typeface employed in *Arts et métiers graphiques*, it has a similar flavor.

Peignot's productions serve as an appropriate typographic model for this collection of photographs, which is heavily weighted toward the modernist, interwar period in Paris. Peignot played an important role in this era. On occasion, his bimonthly magazine carried articles about photographers and their subjects and techniques. In 1930 he initiated an annual review titled *Photographie*, which included many of the photographers in our selection. He published Brassaï's remarkable first book, *Paris de nuit*, in 1933. (D.T.)